IMAGES
of America

HUDSON

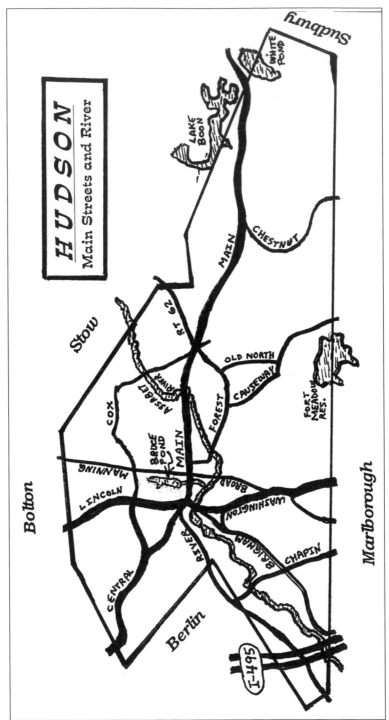

MAP OF HUDSON. The boundary of Hudson somewhat resembles a fish, which is appropriate since the town is built around the Assabet River. Originally, Hudson was an industrial suburb of the town of Marlborough and was named Feltonville. On March 19, 1866, the Massachusetts General Court approved the creation of the town of Hudson.

IMAGES
of America

HUDSON

Lewis Halprin
and the Hudson Historical Society

ARCADIA

First printed in 1999.
Reprinted in 2000, 2001.

Published by Arcadia Publishing,
an imprint of Tempus Publishing, Inc.
2A Cumberland Street
Charleston, SC 29401

Printed in Great Britain.

Library of Congress Catalog Card Number applied for.

For all general information contact Arcadia Publishing at:
Telephone 843-853-2070
Fax 843-853-0044
E-Mail sales@arcadiapublishing.com

For customer service and orders:
Toll-Free 1-888-313-2665

Visit us on the internet at http://www.arcadiapublishing.com

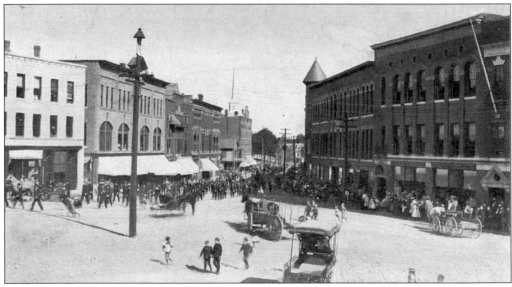

TOWN CENTER. The center of the town of Hudson was Wood Square, where several main streets converged into a large open area dominated by a huge street lamp.

Cover Image: **FLAG BELLES.** Eight suffragettes lead the parade for the 50th anniversary of Hudson on July 4, 1916. They are, from left to right, as follows: (front row of flag) Bernice Peters, Gertie Hobbs, and Ethel Peters Hallowell (not shown); (center row of flag) Bertha Seymour and Mrs. Marsh; (back row of flag) Pearl Kidston, Hazel Kimmens, and Jennie Holyoke.

CONTENTS

HUDSON TOWN SEAL. The town adopted this seal shortly after separating from the town of Marlborough in 1866. Before that date, Hudson was a suburb of Marlborough called Feltonville.

ACKNOWLEDGMENTS

LEWIS HALPRIN While working on the Arcadia book *Lake Boon*, the recreational lake located in the eastern part of Hudson, I became aware of the fantastic collection of images that the Hudson Historical Society had on file. Arcadia agreed to publish a book on Hudson (the one that is in your hand), and so began my adventure with Hudson's history. I was aided by the wonderfully informed and helpful people of the historical society. Especially helpful were Meg Fillmore, who knows everything historical about the town; Kay Johnson, who knows where everything is located in the society's files; and Rosemary Rimkus, who could find needed pictures that were not in the files. We hope that you enjoy our efforts as much as we do.

KATHERINE JOHNSON, HUDSON HISTORICAL SOCIETY MUSEUM HISTORIAN. The pictures chosen for this book present an overview of Feltonville and Hudson, spanning 200 years. It is easy to see in the images within this selection the changes in modes of transportation from horses to trolley, to autos, and to space vehicles. Our home lives and occupations have changed just as dramatically. In appreciating the past, we can more easily understand the present and plan for the future. Hudson has a great past. Every person living in a community contributes to that community's fabric and helps to create its future. In Hudson, your contributions today will be part of the town's future heritage.

INTRODUCTION

*A Brief History of Hudson
by the Hudson Historical Commission
and the Hudson Historical Society*

Hudson, a southern Middlesex County town of more then 18,000 residents, is situated near the second waterfall of the Assabet River and lies within a bowl of hills with little Mount Assabet rising in the center.

In 1698, a settler named John Barnes was granted an acre of the Ockookangansett Plantation, Native-American land which had recently been added to Marlborough's acreage. On the northern bank of the Assabet, he built a gristmill. Within two years, a sawmill was constructed, and the river was bridged so that the road might continue to neighboring Lancaster. Lancaster, at that time, reached almost to Wood Square.

The next century and a quarter brought slow growth to this section of Marlborough, known as the Mills. Several small industries huddled close to the mill area. Stretching to the north and east were a number of large farms. In the early years, relations with the Native Americans were very good. Later, as the Native Americans lost more and more acres, they tried to drive the settlers out and take their land back.

In June 1743, Samuel Witt, John Hapgood, and others residing in the former Native American plantation claimed that "it is vastly fatiguing to attend meeting," and petitioned the General Court to set off this portion of Marlborough as a distinct parish or town. The court refused the plea. The same Samuel Witt was a member of the Committees of Correspondence during the Revolution. On April 19, 1775, when word came of the British march to Concord and Lexington, several men from the present-day Hudson area joined their minutemen companies and marched to Cambridge to contain the British soldiers after their retreat.

In 1819, Lucy Goodale, daughter of one of the area's most successful farmers, married Asa Thurston and went with him to Hawaii with a band of the first missionaries. In the mid-1800s, the little community, now called Feltonville after its wealthiest and most popular merchant, boasted a post office and a hotel. The village was connected to Boston and other towns by stagecoach routes that went by way of Cox Street to Sudbury and then east to the city.

In 1859, the village received the dual blessings of steam power and railroads. Factories opened up all across Feltonville and became among the first to use steam power and to adopt new sewing machines. By 1860, the village had 17 shoe or shoe-related industries. Immigrants

from Ireland and French Canada arrived to join settlers' descendants in working at the 975 local jobs available.

When the call to arms came in 1861, Feltonville citizens were ready, for they had long been ardent abolitionists. Several local homes were stations in the Underground Railway, including the Goodale home on Chestnut Street and the Curley home, known then as the Rice farm, on Brigham Street. Many young men went to fight for the Union cause, and 25 of them died doing so.

In 1865, with the war over, there was once again a move to make Feltonville a corporate town. Again, citizens of Feltonville pointed out the difficulty of attending town meetings (perhaps even losing a day's work on the farm), their lack of access to town records, and the fact that they paid for a high school that was too far to be practicable for their children to attend. A number of meetings were held in Union Hall and in the neighboring towns of Marlborough, Stow, Berlin, and Bolton. Petitions were sent to the Massachusetts General Court asking that a new town be incorporated from an area comprising the northern section of Marlborough with a bit from Stow. On March 19, 1866, the petitions were approved. Hudson officially became a town, named for childhood resident Charles Hudson, who offered $500 toward a library.

Two years later, 100 Bolton voters, who were more closely associated with Hudson than with their own town three miles away, petitioned their town to sell the 2 square miles of land where they lived to the new town of Hudson. Bolton agreed to do so for $10,000, enlarging Hudson's area to 11.81 square miles.

The future of the new town looked good. Industries housed in modern factories became more diversified and attracted new residents. Two woolen mills, an elastic-webbing plant, a piano case factory, and a factory to waterproof fabrics by rubber coating were added to the town. Within a space of 20 years, banks were established and five new schools were built, as was a poor farm. A beautiful new town hall was built to provide a meeting place as well as to house town offices. Most of the 5,500 citizens lived in small, neat homes with backyard garden plots. Five volunteer fire companies, some directly connected with shoe factories, protected the mostly wooden structures of home and industry. One of the fire companies manned the Eureka Hand Pump, which set a record by throwing a 1.5-inch stream of water 229 feet.

On July 4, 1894, disaster struck the thriving town. Small boys who were playing with firecrackers at the rear of a factory on the banks of the mill pond started a fire that destroyed more than 40 buildings and more than 5 acres in the heart of the town. Telegraph operators summoned aid from neighboring towns, and Boston sent apparatus on railroad flatcars, but within three hours time, shops, stores, markets, professional offices, livery stables, a hotel, social clubs, and homes were reduced to rubble. The estimated cost of damages was set at $400,000, with insurance covering $325,000 of that cost. Within a year, a new town rose like magic. All but one of the destroyed business buildings had been rebuilt, a testament to the courage and will that has characterized the citizens of Hudson since its inception.

After 1900, the population grew slowly to 7,500. Some of the homes in town were wired for electricity, now that Hudson had its own power plant. Electric trolley car lines were constructed, connecting Hudson to Leominster, Concord, and Marlboro. The factories grew and attracted many immigrants from foreign countries, including England, Germany, Portugal, Lithuania, Poland, Greece, Albania, and Italy. The immigrants usually lived in crowded boardinghouses near their places of employment. By 1928, 19 different languages were spoken among the workers at the Firestone-Apsley Rubber Company. Today, the predominant foreign language spoken in Hudson is Portuguese.

The population of Hudson changed little until after World War II, when developers claimed many of the farms that still rim the town. Occupants of the new homes that were constructed more than doubled the number of Hudsonians. The population of the town also began to change through an influx of high-technology companies and their attendant employees and families.

In spite of larger numbers, Hudson continues to have a traditional town meeting form of government, though a town administrator now coordinates the operating departments of the town. In 1973, Hudson was declared one of the first Bicentennial Towns of Massachusetts and was given a federal grant of $7,000 to improve Wood Park and make it more beautiful, useful, and enjoyable to townspeople of all ages.

More than 18,000 residents live peacefully in this small valley. With the help of involved citizens, the town moved into the 21st century to meet new challenges with the same undaunted spirit and enthusiasm that helped it overcome the hardships of the past.

IMAGE CREDITS

The Hudson Historical Society was founded 85 years ago. To its early members, we show gratitude for collecting pictures, photographs, and history. The current volunteers at the society's museum continue this effort by collecting contemporary photographs and information, which will be part of tomorrow's history. Most of the images in this book are from the society's collection. Those images that have been borrowed from other collections have the name of the donor in parentheses at the end of the caption of the photograph. Those collections are as follows:

(Durand)	Albert Durand collection.
(Fillmore)	Meg and Ralph Fillmore collection.
(Rimkus)	Rosemary and Vic Rimkus collection.
(Stark)	Joseph Stark collection.
(Worcester)	*Worcester Telegraph* newspaper.

The society has available at its museum a large collection of other images and historical information about the town. Recommended are *Hudson 1966*, a selection of old Hudson images; *Bicentennial Scrapbook*, a paperback book on Hudson's history; *Lake Boon*, a book of images of the lake's recreation days; and the Hudson Throw, a cotton coverlet featuring historic scenes.

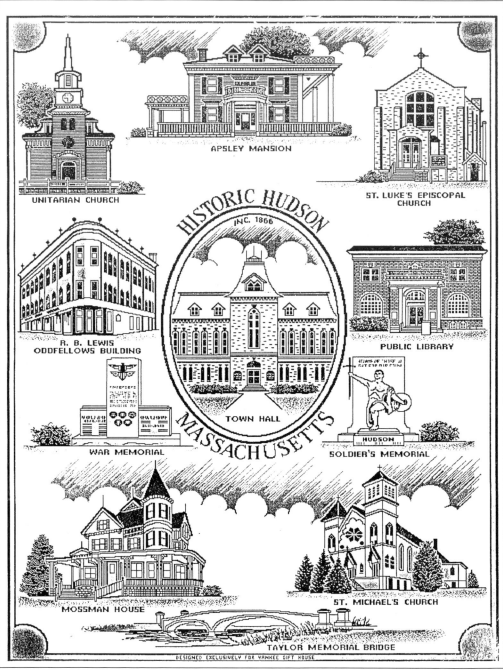

HISTORIC HUDSON

INC. 1866

MASSACHUSETTS

UNITARIAN CHURCH

APSLEY MANSION

ST. LUKE'S EPISCOPAL CHURCH

R. B. LEWIS ODDFELLOWS BUILDING

PUBLIC LIBRARY

WAR MEMORIAL

TOWN HALL

HUDSON

SOLDIER'S MEMORIAL

MOSSMAN HOUSE

ST. MICHAEL'S CHURCH

TAYLOR MEMORIAL BRIDGE

DESIGNED EXCLUSIVELY FOR YANKEE GIFT HOUSE

HUDSON THROW. Shown above is the design of the cotton throw, a coverlet created for the Hudson Historical Society in 1997, showing some of the town's historical points of interest.

One
OUR EARLY HISTORY

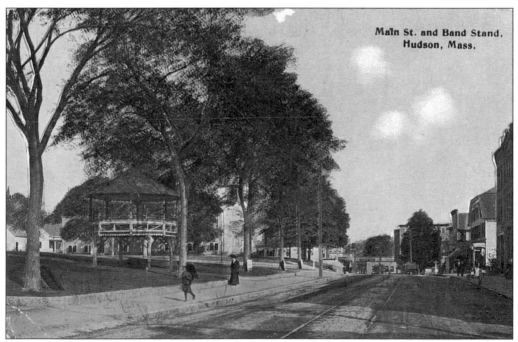

Main St. and Band Stand,
Hudson, Mass.

MAIN STREET. The bandstand on the left was located in front of the town hall. The trolley tracks in the street led to the towns of Stow, Maynard, and Acton.

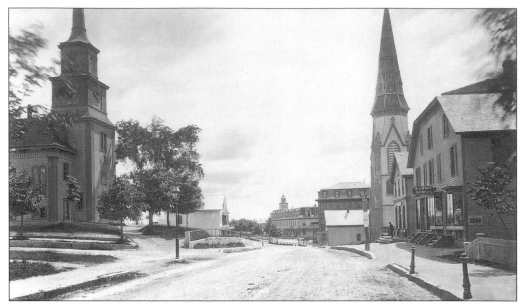

MAIN STREET, EAST FROM TOWN HALL. Pictured here on the left is the Unitarian church and on the right, the Methodist church. Note the hitching posts and gas lamps.

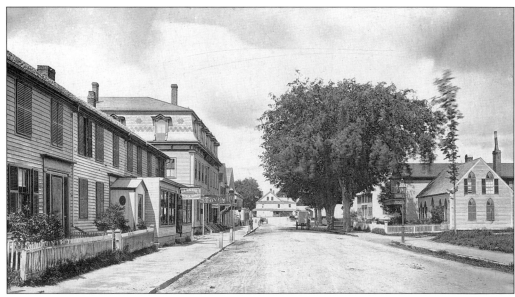

MAIN STREET, WEST FROM TOWN HALL. The small house on the right was moved to South Street. It served as a residence for a time, and is now the popular Horseshoe Pub.

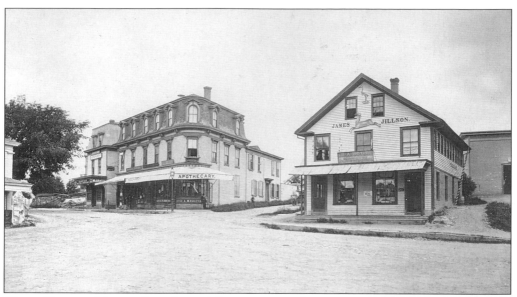

WOOD SQUARE, NORTH SIDE. James Jillson was a taxidermist, as noted by the deer and bird in this storefront at the corner of Felton Street.

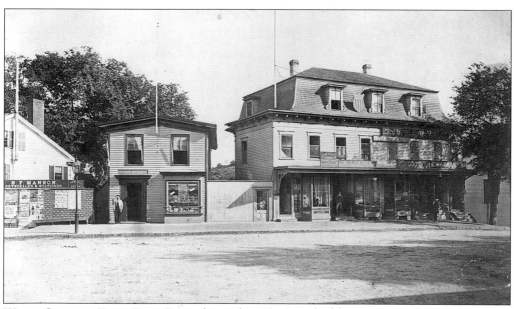

WOOD SQUARE, EAST SIDE. Since the mid-1800s there had been a post office in the Felton store (which provided the town's early name—Feltonville). When B.F. Manson became the postmaster of Hudson, he built Hudson's first post office building next to his store, shown in the center of this picture. The building on the right is the Brigham Block, which housed the town's first savings bank and first library.

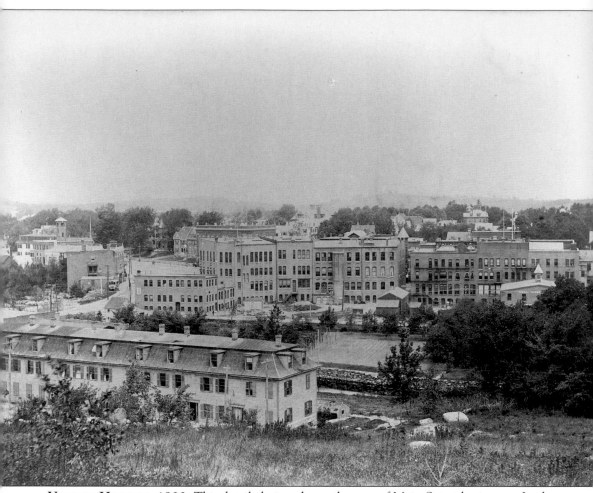

VIEW OF HUDSON, 1900. This detailed view shows the rear of Main Street businesses. In the foreground is the School Street Block that initially housed several of Hudson's influential people and later became the residence for many of the mill workers.

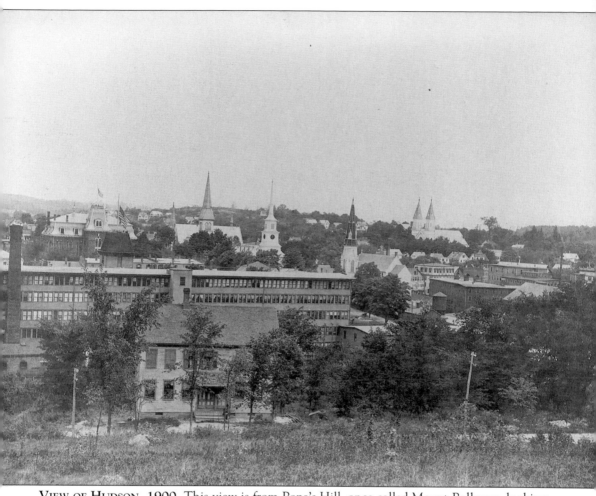

VIEW OF HUDSON, 1900. This view is from Pope's Hill, once called Mount Bellevue, looking north to Hudson. House lots were laid out on this hill for a quantity of quality homes, but at the time, it was not feasible to pump water up the hill to serve the houses and so the development was discontinued.

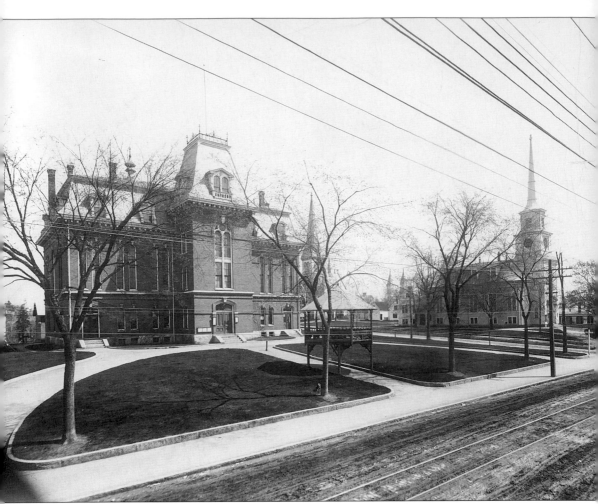

TOWN HALL. This stately structure was built from 1871 to 1872 and was dedicated on September 26, 1872. Over the years, it has housed the town offices, a library, a banking room, a schoolroom, and a district court, at various times. The second floor has a large hall for town meetings and entertainment. The third floor was used for Masonic purposes and is now the home of the Historical Society Museum. The foundation of the hall is made of Townsend granite. The exterior is brick with granite trimmings, crowned with a French roof and ornamental railing fence. The master builder for this project was C.H. Robinson of Hudson. In 1999, the interior was restored, redecorated to its original beauty, and adapted to modern technologies.

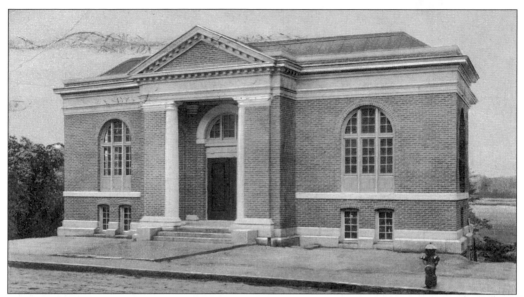

LIBRARY BUILDING. This library was built in 1905, financed with $12,500 from philanthropist Andrew Carnegie and $1,500 from the town. The original structure has been enlarged both upward and outward in several stages to meet the demands of a growing community.

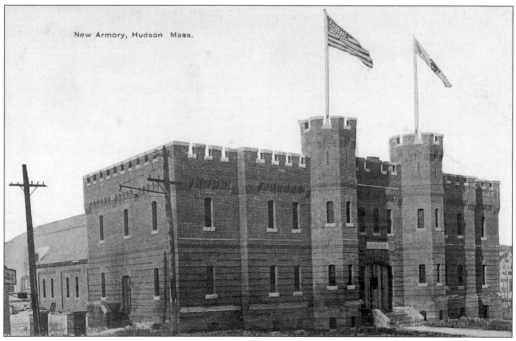

New Armory, Hudson Mass.

NATIONAL GUARD ARMORY. The National Guard Armory on Washington Street was dedicated on December 31, 1910. It was built on the former Marshall Wood estate.

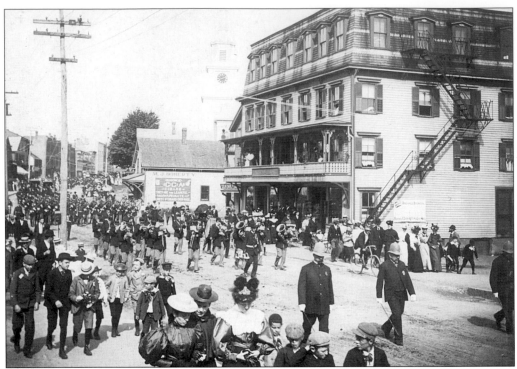

AMERICAN HOUSE. This photograph shows a parade marching down Main Street past the American House, which was built in the 1860s and torn down in 1935. (Fillmore.)

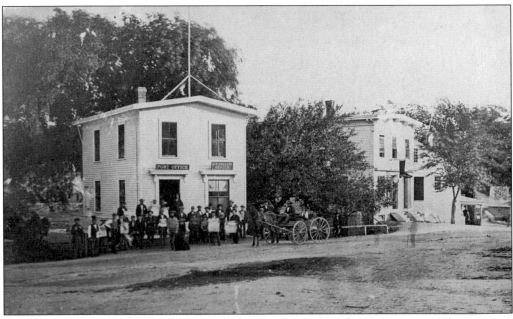

POST OFFICE BUILDING. The first post office was located in the Peters store. When George Manson became postmaster in 1850, he erected the building shown here. Later, this building was moved to Warner Street, where it was used as a home. Brigham's Block was built on the former site.

HOUGHTON PARK FOUNTAIN. This fountain was located on the corner of Main and Broad Streets.

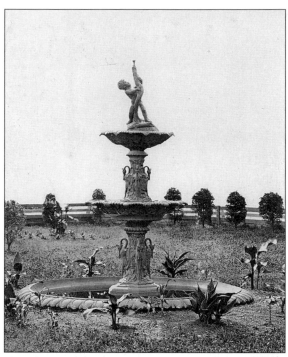

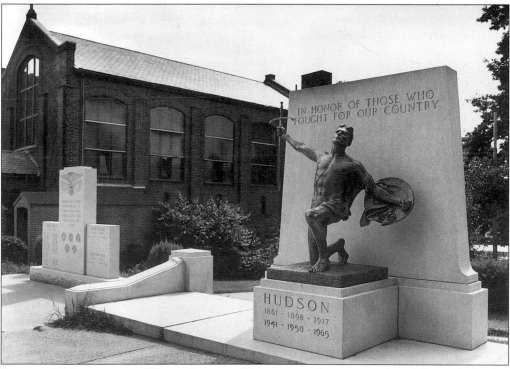

SOLDIERS' MEMORIAL IN WOOD SQUARE. This memorial was erected in Liberty Park after World War I to honor all veterans. In 1966, a second memorial was added to the side of the original memorial and on it were inscribed the names of the veterans who died in the Korean and Vietnam Wars.

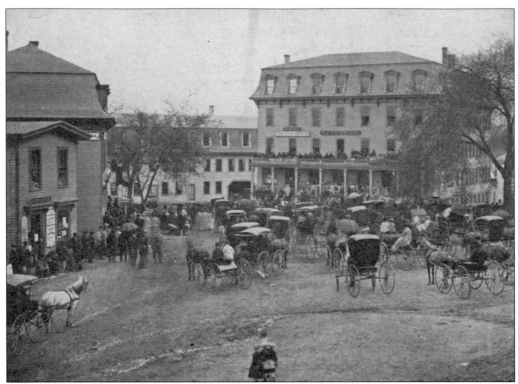

WOOD SQUARE WITH HORSE AND WAGONS. The newly formed town of Hudson celebrated its first Memorial Day on May 30, 1869.

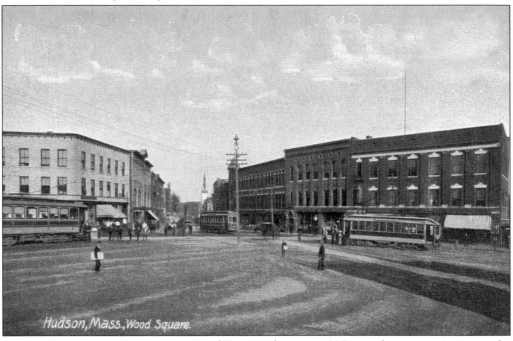

WOOD SQUARE WITH TROLLEYS. Wood Square, shown c. 1900, was the connecting point for three streetcar lines.

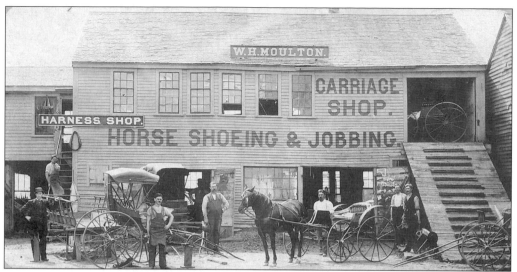

MOULTON HARNESS SHOP. Located between the Brigham and Trowbridge factories was this very busy harness and carriage shop, which kept the wagons and their gear in top operating form.

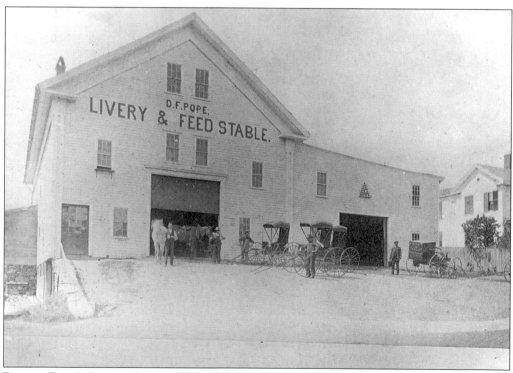

DANIEL POPE'S LIVERY STABLE. Daniel Folger Pope operated a livery stable for many years on Pope Street. This picture was taken *c.* 1894.

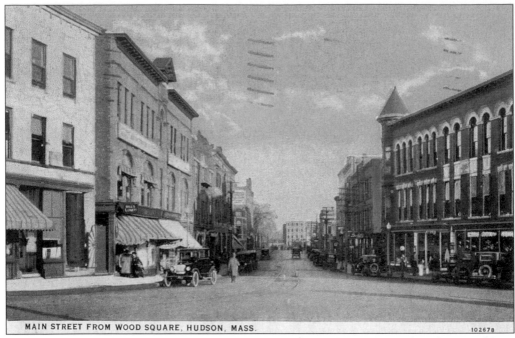

MAIN STREET FROM WOOD SQUARE, HUDSON, MASS.

102678

MAIN STREET FROM WOOD SQUARE. Seen on the right of this image is the Chase Building, which burned in the 1935 fire.

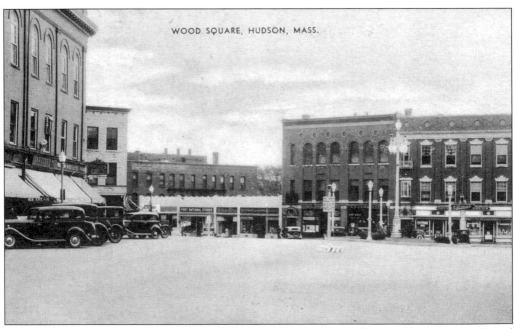

WOOD SQUARE, HUDSON, MASS.

WOOD SQUARE WITH OLD CARS. By 1938, the wagons, horses, and trolley cars in Wood Square had given way to automobiles and paved roads.

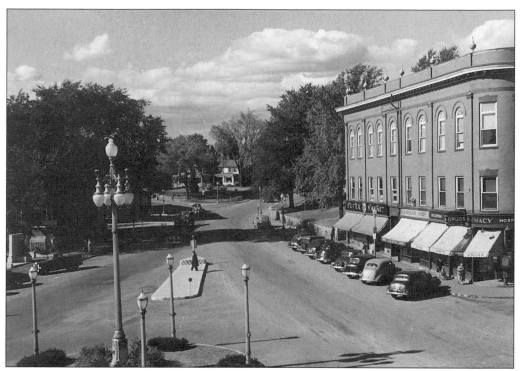

WOOD SQUARE LOOKING NORTH. The Lewis Block is shown on the right in this photograph. The town experimented with diagonal parking around Wood Square.

WOOD SQUARE WITH NEWER CARS. As the 20th century proceeded, the size and the number of cars increased. This is what Wood Square looked like by 1960.

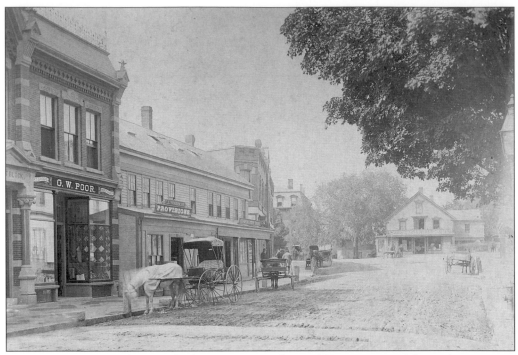

OLD MAIN STREET. This view looking west toward Wood House is one of the earliest pictures of Main Street.

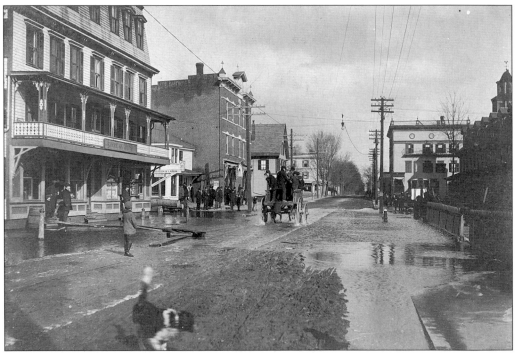

AMERICAN HOUSE. The first building pictured on the left is the American House, and the next building belonged to Robertson & Larkin. Note the streetlight over the middle of the dirt road and the stagecoach passing under it.

Two
PUBLIC PERSONALITIES

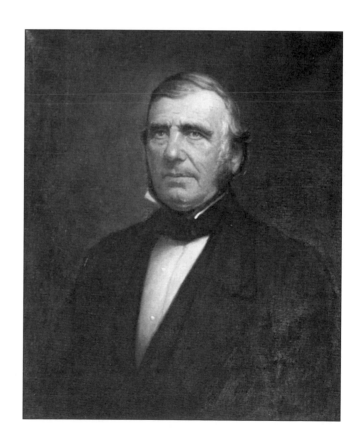

CHARLES HUDSON. Charles Hudson, the man after whom the town of Hudson was named, was an author, statesman, minister, public servant, senator, state representative, U.S. congressman, and historian.

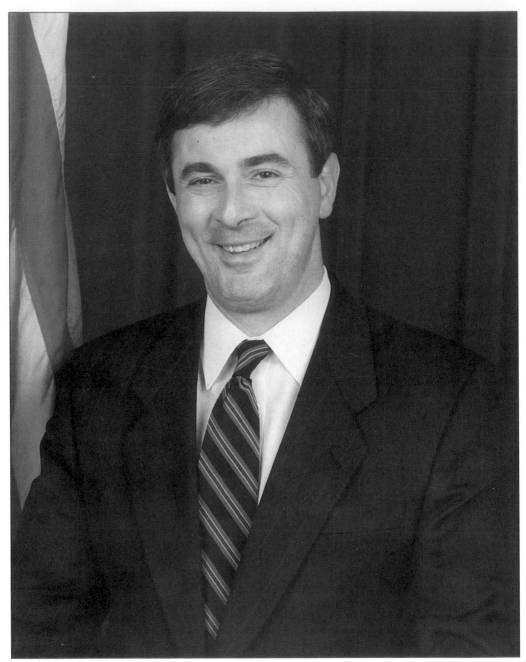

ARGEO PAUL CELLUCCI, GOVERNOR OF MASSACHUSETTS, 1998. Paul Cellucci, a native of Hudson, began his political career as a town selectman. He served as a state senator, lieutenant governor under Gov. William Weld, and acting governor from 1996 to 1998.

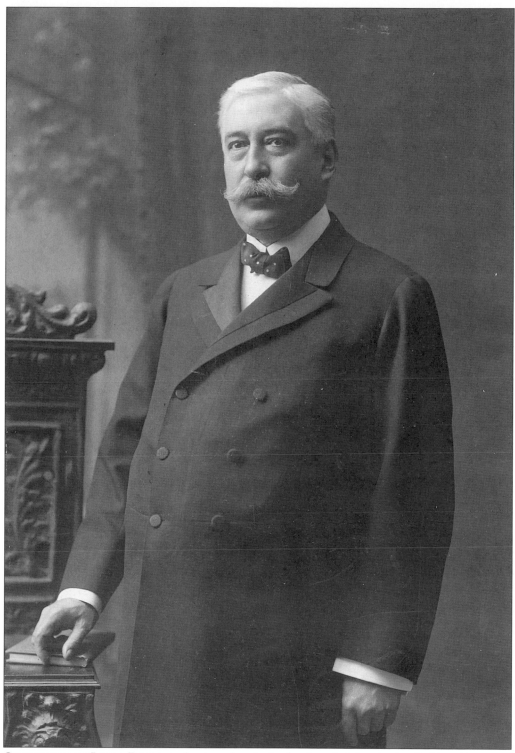

CONGRESSMAN LEWIS DEWART APSLEY. Lewis Apsley founded the Apsley Rubber Company in 1892. He was a U.S. congressman from 1892 to 1896, a philanthropist, and a public servant.

FRANCIS BRIGHAM. Francis Brigham was born in 1813. At age 23, he built the first shop for the manufacture of pegged shoes. In 1847, he built a larger factory, and then, *c.* 1860, he built a bigger brick factory for 300 employees on Washington Street next to the Assabet River. Large quantities of shoes were made for soldiers during the Civil War, and Brigham's company was the oldest shoe manufacturer in America at that time. A significant landowner, Brigham served in the state house of representatives (as a selectman) and as the first president of the Hudson Savings Bank.

BENJAMIN DEARBORN (1826–1891). Benjamin Dearborn, a mason and builder, commenced business in 1857. In that year, he built the brick shop for F. Brigham & Company. He went on to construct nearly all of the brick buildings in Hudson that predate 1889.

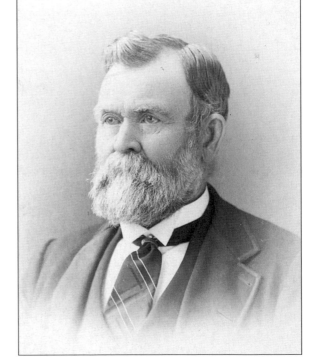

COL. ADELBERT MOSSMAN (1848–1945).
Adelbert Mossman was a Hudson jeweler between 1876 and 1900. He was appointed assistant adjutant general of the commonwealth and was the state's sergeant at arms for 30 years. He organized Hudson's first military company in 1887. For 50 years, he was a corporator of the Hudson Savings Bank.

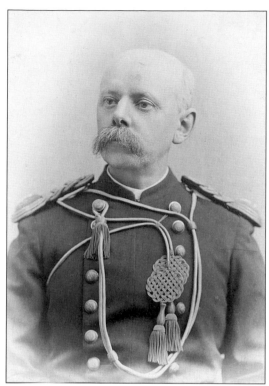

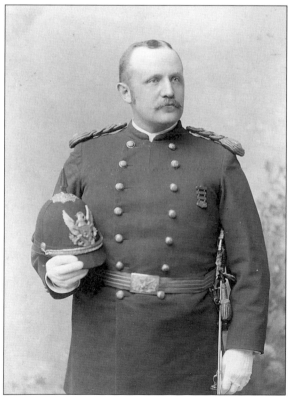

BRIGADIER GEN. WILLIAM H. BRIGHAM (1863–1911). William Hartwell Brigham was born in Hudson in 1863. After completing school, he entered the employ of his father in the grain business. His grandfather, Francis Brigham, owned the first shoe factory in Hudson. William became the third generation to run this company. He also served as a selectman for seven years. He was elected to the Massachusetts House of Representatives in 1892, and to the state senate in 1897. He was a prominent member of the state's military, working up from first lieutenant to brigadier general of the Mass Militia, and was responsible for having the armory built in Hudson.

THOMAS TAYLOR. In 1882, Thomas Taylor came to America from Derby, England. He first worked with an Easthampton, Massachusetts, shoe company. Then, in 1888, he came to Hudson and founded the Thomas Taylor & Sons company.

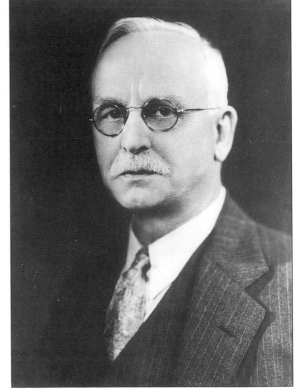

FRANK TAYLOR. Frank Taylor was one of two sons of Thomas Taylor, both of whom worked at the Thomas Taylor & Sons company. His brother Thomas Taylor Jr. died prematurely. When Thomas Taylor Sr. died in 1923, Frank Taylor became the sole owner of the company.

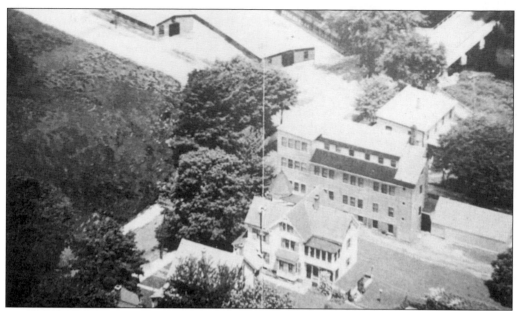

THOMAS TAYLOR & SONS FACTORY COMPLEX. In 1888, Thomas Taylor moved his shoe goring business to Hudson. Thomas Taylor & Sons achieved the reputation of producing outstanding quality shoe goring, and the company was run by three generations of the family.

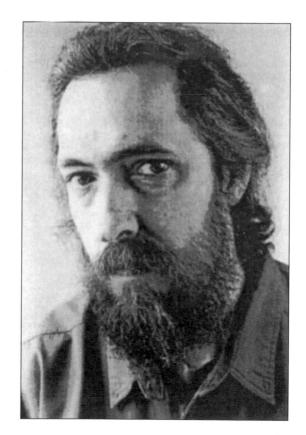

DAVID PONTBRIAND. Hudson artist David Pontbriand is famous for painting the American landscape. He "discovered" painting at the former Hudson Institute, where he studied under Ann Wallace and John Bageris. His Hudson Public Library shows were annual events from 1971 to 1975.

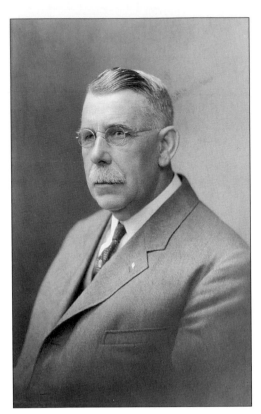

Henry T.G. Dyson. A native of Barnsley, England, Henry Dyson came to Hudson in 1896 to establish the first wool combing plant in the United States. He was a cofounder of St. Luke's Episcopal Church and the donor of the first Honor Roll memorial after World War I. He served in the state legislature and as a town official.

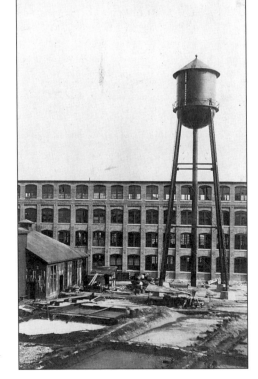

Hudson Worsted Company. Henry Dyson constructed this building on Broad Street in 1903. The Hudson Worsted Company employed 750 people.

ARGEO E. CELLUCCI JR. Argeo Cellucci, the father of Gov. Paul Cellucci, has been Hudson's industrial commissioner for over 35 years and has been responsible for bringing many businesses, both large and small, to Hudson. A native of Hudson, he graduated from Hudson High School in 1940 and later succeeded his father, Argeo Cellucci Sr., as head of the automobile business and Oldsmobile dealership on Washington Street.

WILLIAM SULLIVAN, ASSISTANT DIRECTOR OF FBI. For 30 years, William Sullivan served in the FBI as a deputy to J. Edgar Hoover. Sullivan graduated from Hudson High School in 1930.

WILFRED BALTHAZAR. Wilfred Balthazar served in the Massachusetts House of Representatives from 1963 to 1978. He also was town counsel and a Hudson selectman.

FANNIE BUZZELL DETTLING. Fannie Dettling served in the Massachusetts House of Representatives from 1948 to 1952. She also was town counsel, a school committee member, and part of the original Assabet Valley Regional High School building committee.

THOMAS P. SALMON. Thomas Salmon was born in Cleveland, raised in Stow, and attended Hudson High School, where he was a member of the football and hockey teams. In 1973, he became governor of Vermont, only the second Democratic governor in the state's history. He served for two terms.

BURTON K. WHEELER, U.S. SENATOR. Burton Kendall Wheeler was born in Hudson on February 27, 1882, at the old Wheeler homestead. He graduated from Hudson High School in the Class of 1900. He was elected to the Montana state legislature and later was appointed as a U.S. district attorney. He was elected to the U.S. Senate in 1922, and for 24 years, he served as Montana's senator.

WILBERT ROBINSON, HALL OF FAME BASEBALL PLAYER. Hudson native Wilbert "Uncle Robbie" Robinson was the star catcher for the famous pennant clubs of the Baltimore Orioles in 1894, 1895, and 1896. He set a record of seven hits in seven times at bat in a single game. Robinson later won fame as manager of the Brooklyn Dodgers, from 1914 through 1931.

JEREMIAH O'NEIL. Jeremiah is the father of Julia O'Neil McQuillan and the grandfather of William, Elizabeth, and Jeremiah McQuillan.

CHRISTOPHER GOREY, ARTIST. Christopher Gorey graduated from Hudson High School and then from the Massachusetts College of Art. He taught art in Massachusetts and spent summers in Atlantic Canada. Finding the lifestyle and open spaces of Nova Scotia much to his liking, Gorey moved to Cape Breton Island, where he has become internationally known.

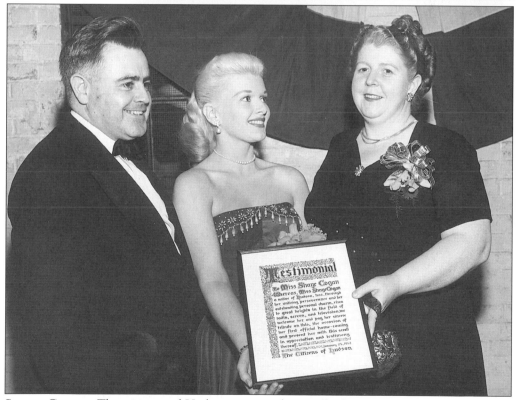

SHANE COGAN. The citizens of Hudson presented a scroll of appreciation to Hudson-born, popular radio, screen, and television singer Shaye Cogan. Shown at the presentation ceremony are unidentified, Shaye Cogan, and the principal of Hudson High School, Helen Glynn.

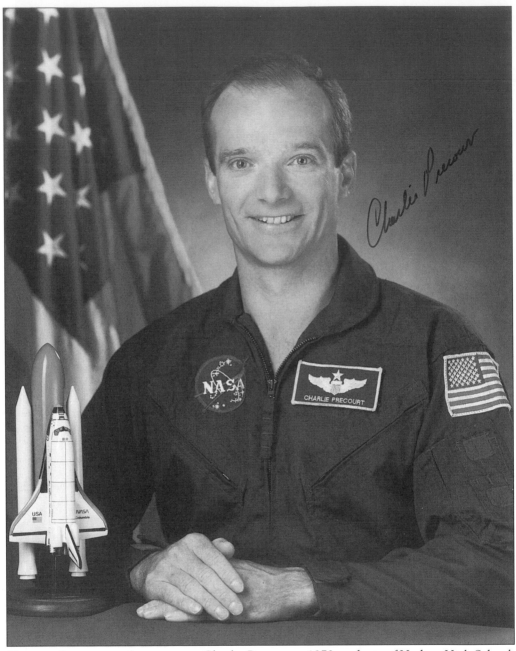

CHARLES PRECOURT, ASTRONAUT. Charles Precourt, a 1973 graduate of Hudson High School, was an astronaut for NASA starting in 1990. He has taken four space flights, including two trips to the Russian space station *Mir*. On his fourth flight, he was the ship's commander.

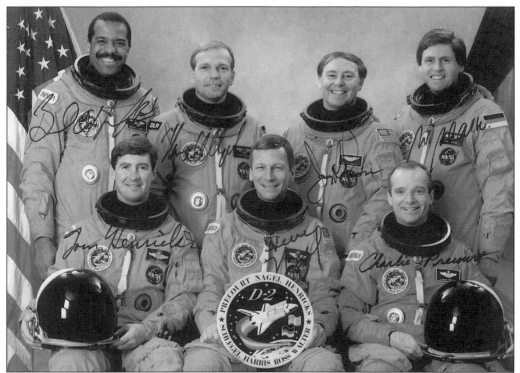

CHARLES PRECOURT AND ASTRONAUT CREW. Charles Precourt, front row right, poses with the crew for the April 26, 1993 flight of the shuttle *Columbia*. Each of the astronauts signed the photograph.

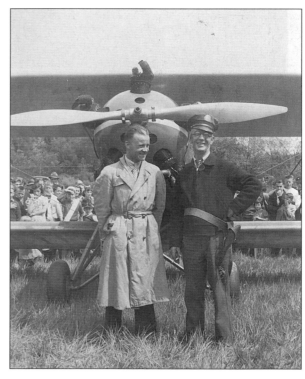

YOUR MAIL IS HERE. Charles Spaulding, pilot, with Ned McCarthy, is shown at the first air mail flight from Hudson on May 19, 1938.

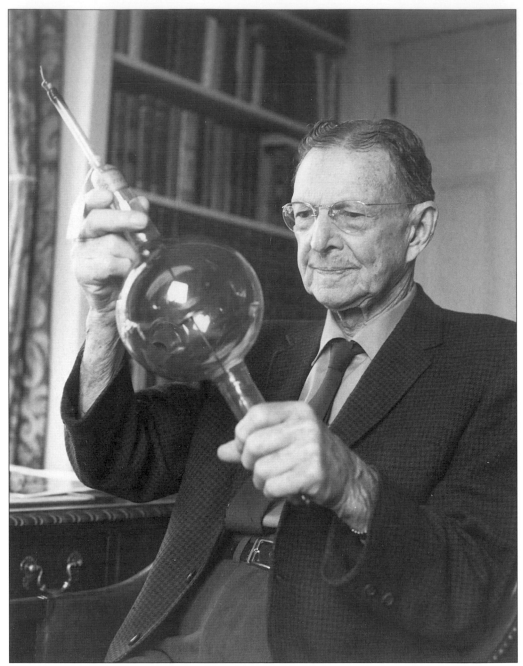

WILLIAM COOLIDGE. Dr. William D. Coolidge, father of the modern X-ray tube, examines an early model of his invention. This photograph was taken in 1967, as the retired General Electric vice president and director of research celebrated his 94th birthday and the 50th anniversary of the issuing of his first X-ray patent. Coolidge died on February 3, 1975, at the age of 101. That year, he was named to the National Inventor's Hall of Fame.

BENJAMIN B. LOVETT. Benjamin Lovett, a Hudson resident in the early 1920s, graduated from Grant's Academy of Dancing in Buffalo, New York, and became a member of the International Association of Masters of Dancing. Among Lovett's dance students at the Wayside Inn, which was in the neighboring town of Sudbury, was Henry Ford, who was a graceful dancer. Ford was so impressed with his instructor's teaching style that he hired Lovett. Lovett sold the five dance halls he owned in the Hudson area and moved to Dearborn, Michigan, where he became a full-time dance instructor for Henry Ford.

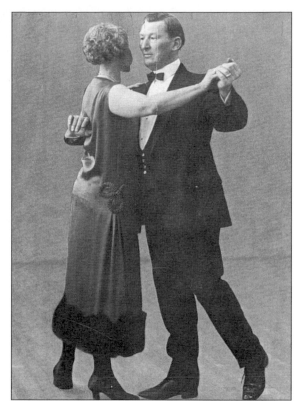

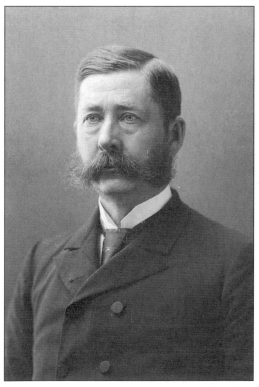

DR. JAMES LANG HARRIMAN (1833–1907). Dr. James Harriman was a physician and surgeon in Hudson for 40 years. He served on the Hudson School Committee for 38 years, and the Harriman School was named in his honor. He was the grandfather of Harriman Reardon, a Hudson businessman and philanthropist.

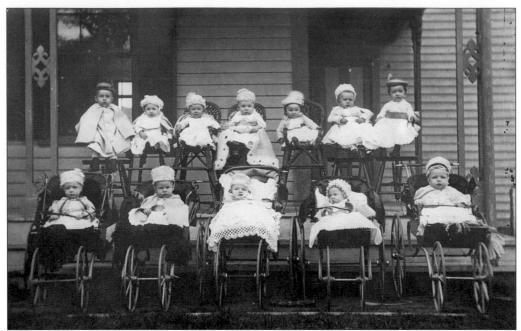

THE MORNING GLORY BEAUTIES. Probably no photograph has ever been given a wider distribution or attracted more attention than the one called *Morning Glories*, by Hudson artist R.B. Lewis. More than 18,000 copies of the picture were sold. Produced in 1874 and exhibited at the Centennial Exposition in Philadelphia in 1876, the photograph was considered a marvel of success since getting so many babies to sit still at the same time was deemed an impossibility. Pictured, from left to right, are the following: (in carriages) Cora Wood, Willie Coolidge, Frank Howe, Maude Stowe, and Charlie Chase; (back row) Earnest Stowe, Bertha Fletcher McGray, Grace Bean, Will Hastings, Lena Morse Allen, Harry Moore, and Harry Ross. (Pg 42, SL-208.)

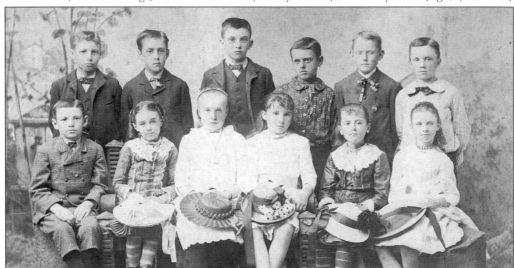

MORNING GLORIES REVISITED. Another view of the famous Morning Glories, by R.B. Lewis, shows, from left to right, the following: (first row) Will Coolidge, Grace Bean, Cora Wood, Lena Morse Allen, Bertha Fletcher McGray, and Maude Stow; (back row) Charlie Chase, Ernest Stowe, Harry Ross, Harry Moore, Frank Howe, and Will Hastings.

Three
HOW WE GOT AROUND

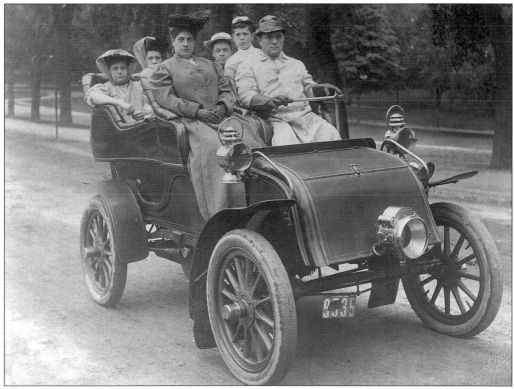

COME RIDE WITH ME. A family takes a ride on a brisk fall Sunday afternoon down the streets of Hudson in their new open-air horseless carriage. Note the tire hubs were built in the same style as a wagon wheel.

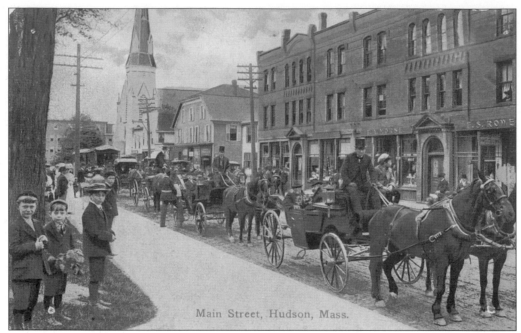

HORSE CARRIAGES. These horse carriages on Main Street, sometime before 1910, may have been for taxi use or a wedding procession. The drivers of the coaches were formally dressed, complete with high top hats.

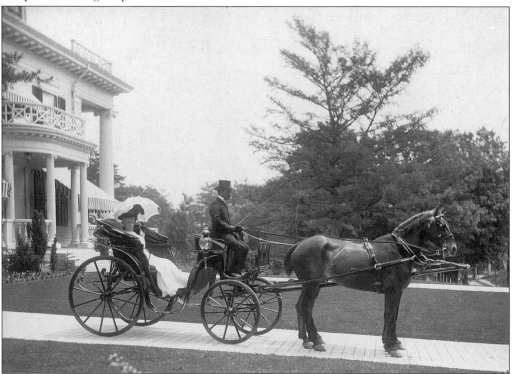

TAKING A SUNDAY RIDE. This horse and buggy in front of the Apsley Mansion is ready to take its owners out for a ride around town.

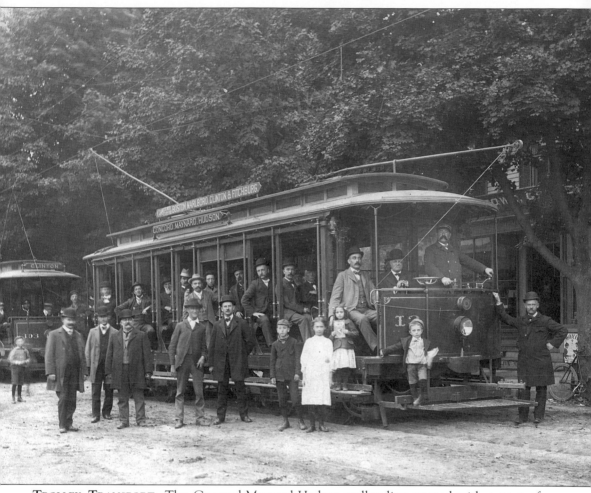

TROLLEY TRANSPORT. The Concord-Maynard-Hudson trolley line opened with a tour of inspection in November 1901. In front of the car is J.W. Ogden, superintendent of the line. Dr. Glazier is on the front seat, wearing a light suit, and Charles Bennett and Rufus Howe are on the end of the next seat.

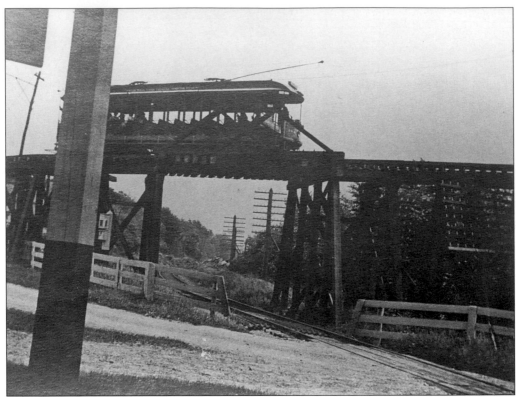

TROLLEY TO CLINTON. This trestle at Stone's Corner on the Hudson-Berlin-Bolton town line enabled trolleys of the Worcester Consolidated Street Railway to pass over the Boston & Maine railroad track and the Route 62 roadway. The trestle and trolley rails were removed in 1926.

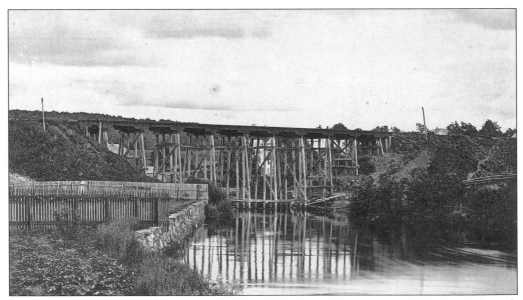

RAILROAD BRIDGE. This bridge at Broad and Houghton Streets served Marlboro's branch railroad.

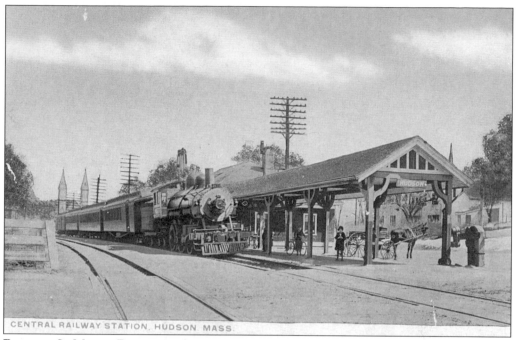

BOSTON & MAINE RAILROAD STATION. At two stations in 1900, 36 trains a day served Hudson on the Boston & Maine Railroad. The station shown here was known as the Felton Street Station.

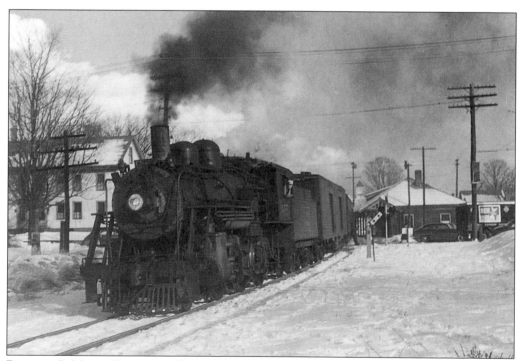

BOSTON & MAINE RAILROAD TRAIN. A Boston & Maine train pauses at the station between Lincoln and Felton Streets.

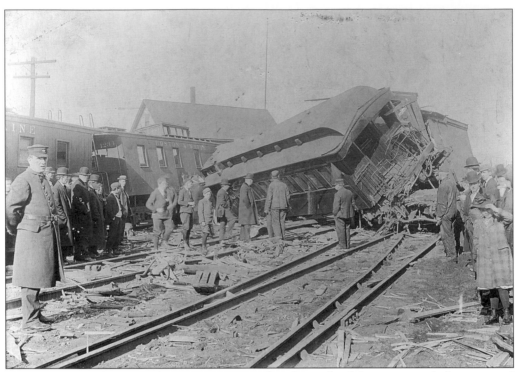

TRAIN WRECK. Townspeople turn out to view the aftermath of the train wreck that occurred on June 7, 1897. (Worcester.)

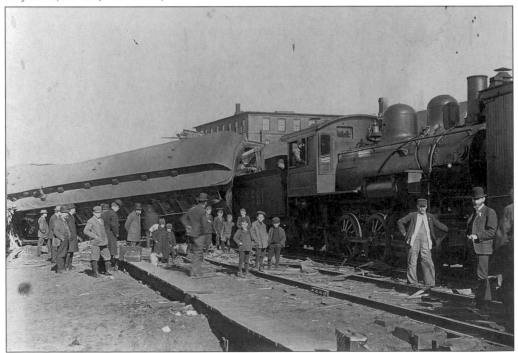

CLEANING UP THE WRECK. Townsfolk watch the train crew clean up the railroad cars that were spilled during the June 7, 1897 train wreck in Hudson. (Worcester.)

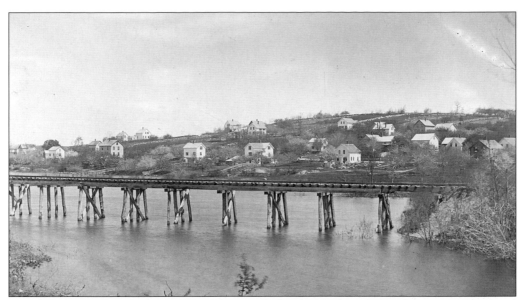

THE RAILROAD THAT NEVER DID. This trestle for the Hudson & South Lancaster Railroad was completed in the late 1800s. The line was almost 9 miles long, beginning near the old downtown station on the Marlboro Branch. The tracks then crossed Main Street, climbed the hill, and spanned the pond on the long trestle, shown in this picture. Then the track went under the Central Massachusetts Railroad line, crossed Cox Street by the lumberyard, swung in a northwest direction, and crossed Lincoln Street, Route 85. The track made a loop into Bolton Center and then headed southwest to join the Worcester, Nashua & Portland Railroad at South Lancaster. The railroad cost more than $220,000 to build, including stations, tracks, and property. However, it was sold in 1883 for only $15,000 after running only one train on its tracks for excursion trips.

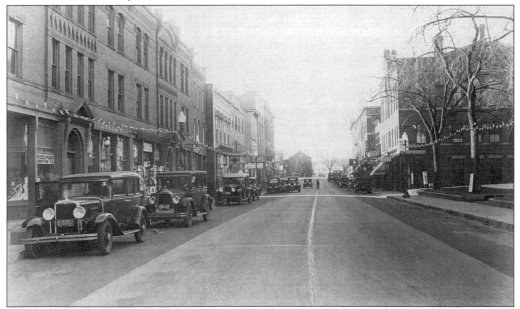

MAIN STREET AUTOMOBILE TRAFFIC. This street was reconstructed out of concrete in 1930 to make it much more durable and more pleasant for automobile travel.

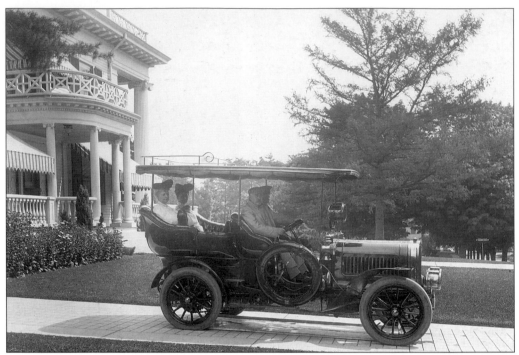

TAKING A HORSELESS DRIVE AROUND TOWN. This fancy horseless carriage in front of the Apsley Mansion is ready to take the family for a Sunday afternoon drive around the streets of Hudson.

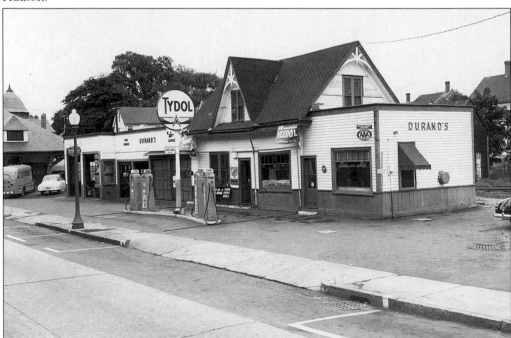

DURAND'S TYDOL STATION. Pictured here is one of Hudson's early gas stations on Main Street, with the Fitchburg railroad station on the left. The center part of the gas station building was formerly the railroad's freight express office. (Durand.)

Four
WHERE WE WORKED

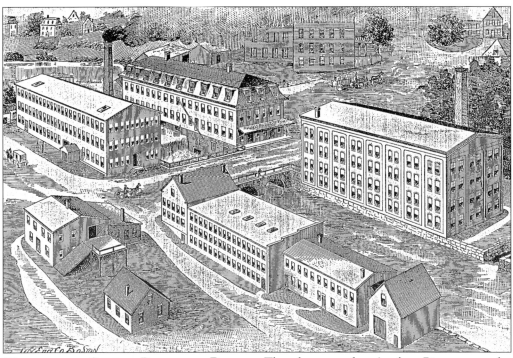

WASHINGTON STREET DAM AND BRIDGE. The dam on the Assabet River near the Washington Street bridge provided waterpower for many of the nearby factories. After its original construction, the height of the dam was raised another 20 inches in order to provide more power from the fickle river.

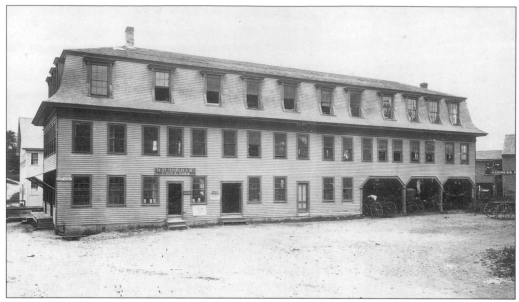

F. Brigham's Shoe Shop. The shoe shop was built in 1847 on the north side of Washington Street beside the dam. The shop burned in the fire of 1894.

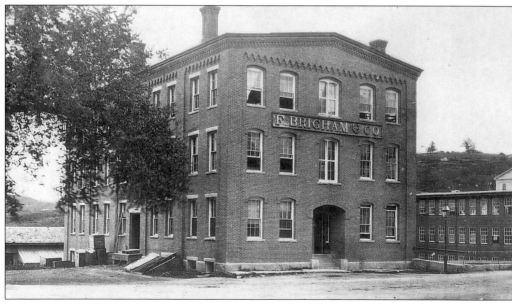

F. Brigham & Company's Shoe Shop. Located on South and Washington Streets, the shop was built in 1859 and burned in 1882. Francis Brigham owned four shoe shops that were powered by the Washington Street dam on the Assabet River.

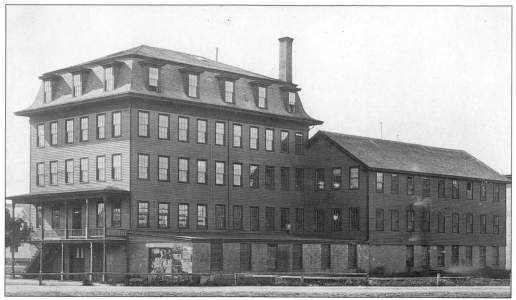

F.S. DAWES'S SHOE SHOP. The Hudson Light & Power started in the cellar of the F.S. Dawes building on Houghton and Main Streets. The building was razed in 1999.

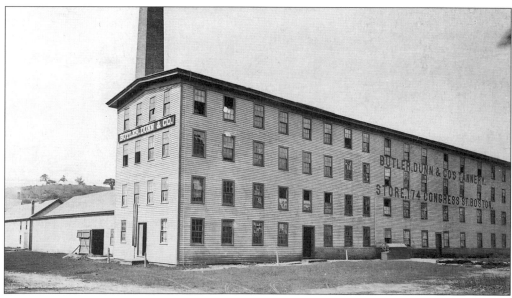

BUTLER, DUNN & COMPANY'S TANNERY. The Butler, Dunn & Company tannery was located on Houghton and South Streets.

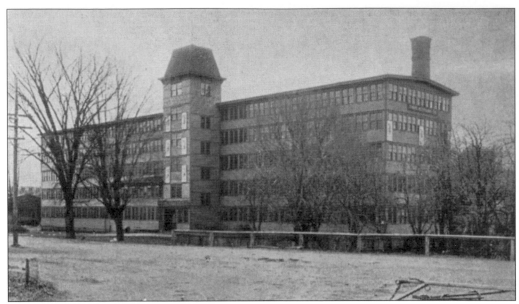

THE F. BRIGHAM & SONS FACTORY BUILDING. The F. Brigham & Sons shoe factory was located on South Street. Later, the Ascutney Shoe Company occupied this building until it burned on October 31, 1968. (Fillmore.)

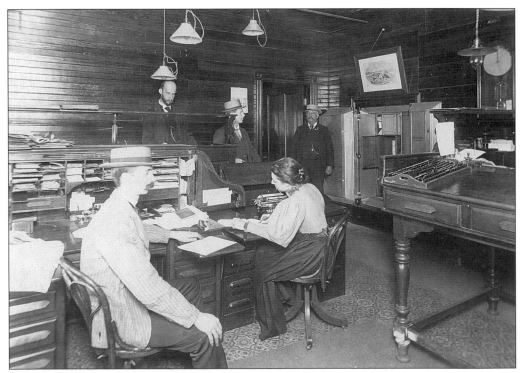

F. BRIGHAM FACTORY OFFICE. This office of the F. Brigham & Sons factory is typical of a 1900s shoe factory office. Rufus Brigham is standing in the doorway. (Fillmore.)

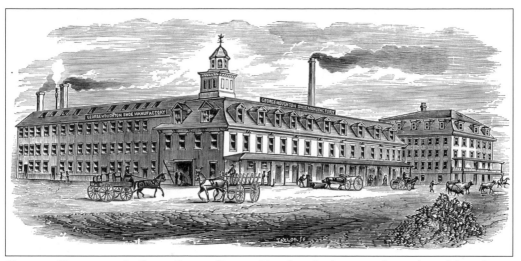

GEORGE HOUGHTON'S SHOE SHOP. George Houghton's shop was located on Main Street between Houghton and Broad Streets.

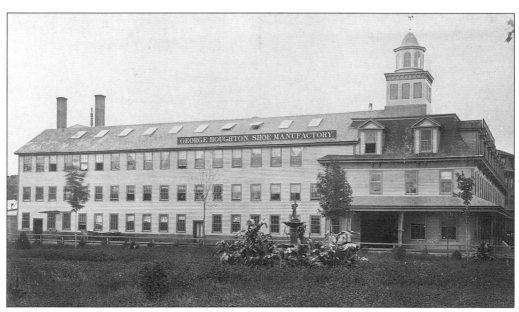

FRONT DOOR AT THE SHOE SHOP. These are the administration offices of George Houghton's Shoe Shop, showing the garden in front of the shop's front door.

HUDSON FABRIC COMPANY'S SHOP. The Hudson Fabric Company's shop, located at the Washington Street bridge, was owned by Francis Brigham.

L.T. JEFTS SHOE SHOP. L.T. Jefts Shoe Shop was located on Broad Street. The building later housed the Braga Shoe Company.

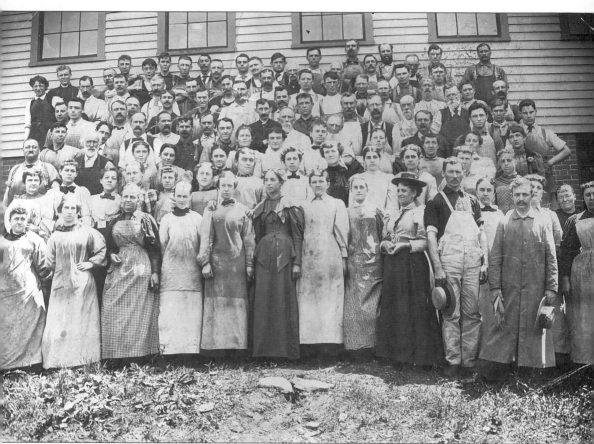

JEFTS SHOE FACTORY EMPLOYEES. Employees pose outside the Jefts Shoe Factory *c.* 1895. They are, from left to right, as follows: (first row) Lola Burnham, Lillie Parmenter, Rebecca Barrows, Rosie Collins, Mary Kenny, Jimnir Martin, Katie Sheridan, Ella Bruce, Mrs. Chambur Descarde, Warren Bigelow, Kate Norman, George Fuller, Gertie Rich, Sarah Taylor, and Carrie Lovejoy; (second row) Marcella Larabee, Kati Doyle, Flora Moore, Jane Plant, Jonnie Peck, Delia Merrill, Camila Boudreau, Jennie Feeny Vallier, Lizzie Sharon, Annie Mahoney, Rose Frances, Josie Chartier, Clara Pines, Lousia Lewis Brown, Irene Sheridan Kelly, Lizzie Tomk, and unidentified; (third row) William Pierce, Henry Patten, Vergie Brown, Nellie Foley, Sadie McCarthy, Louisa Rock, Mary Foley, Mary Eagan Murphy, Angie Macomber Bigelow, Charles Hapgood, Irene Sheridan Kelly, H.P. Bean, Henry Wagner, Herman Bruce, and Millard Lovejoy; (fourth row) Moe Wood, Edmun Stowe, Tom Bouly, M. Savage, W.H. Stevenson, Walter Stevenson, Tom Hapgood, Oliver Sawyer, Lon Chase, Frank Jones, and H.H. Safford; (fifth row) unidentified, unidentified, Edward Cuff, Arthur Holyoke, unidentified, Terrence King, Jim Collins, Alfred Hapgood, and Billy Dillon; (sixth row) Arthur Furlong, Charles Howard, unidentified, Ed Baker, Tom Drummy, Burt Tomka, Frank Wood, Frank Fairbanks, Frank Shortsleeves, James Ryan, Frank Lepine, Joseph Walker, Albert Taylor, Filo Walker, and F. Morrell; (seventh row) Michal McNally, Patrick Reddy, John Collins, Tom Reddy, Patsy Gill, Billy O'Brien, Pete Wood, Ed Stone, Henry LaFrance, Herbert Hyde, Dick Reed, Tom Boyd, Henry Daigneault, Arthur Wood, Seth Darling, Adolphus Daignault, Pete Henfield, Chas Patton, Arthur Warren, William Strong, unidentified, and unidentified.

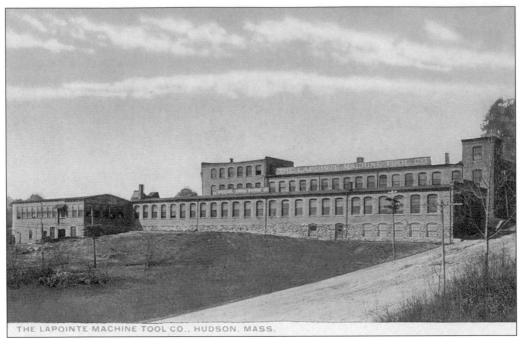

THE LAPOINTE MACHINE TOOL CO., HUDSON, MASS.

LaPointe Machine Tool Company. Located on Tower Street, the LaPointe Machine Tool Company was an internationally known broaching company. It earned numerous defense awards during World War II.

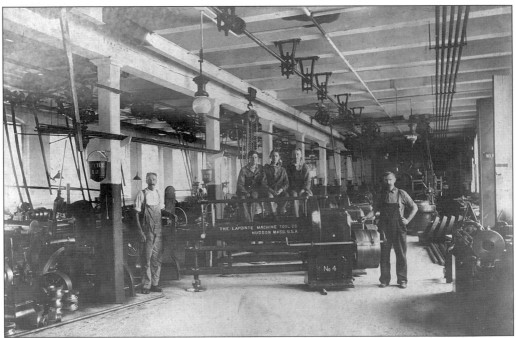

LaPointe Machine Tool Company Workers. The LaPointe Machine Tool Company was famous worldwide for its ability to drill square holes, a skill not many other factories were able to accomplish.

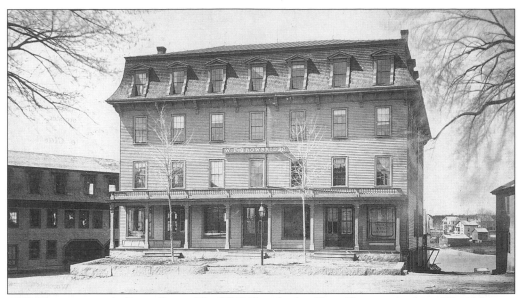

W.F. TROWBRIDGE'S SHOE SHOP. The W.F. Trowbridge Shoe Shop was built on Wood Square in 1866. Stores were located on the first floor, and shoes were made on the upper three floors. No waterpower was used by this shop.

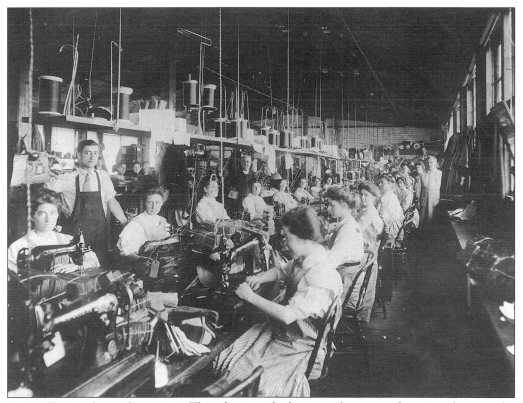

INSIDE BRETT SHOE COMPANY. This photograph shows workers manufacturing shoes at the Brett Shoe Company, *c.* 1915.

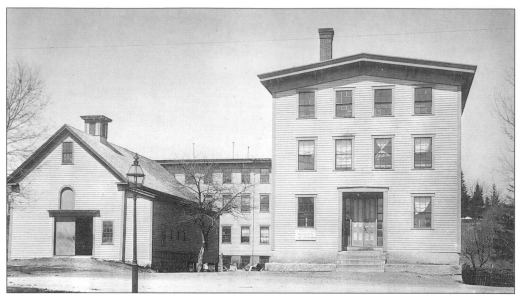

E.M. Stowe's Shoe Shop. E.M. Stowe's Shoe Shop was located on Main Street at Sawyer Lane.

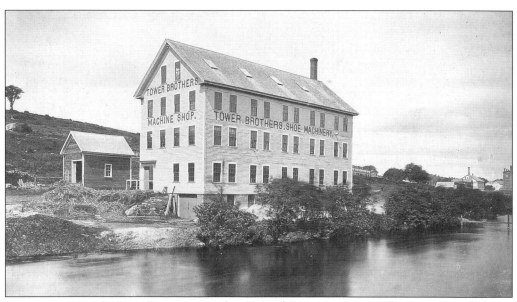

Tower Brother's Shoe Shop. Located on School Street was Tower Brother's Shoe Shop.

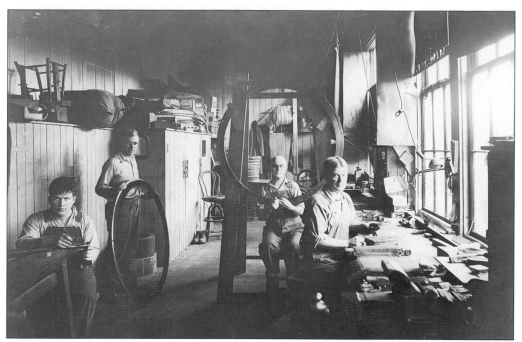

INSIDE HUDSON WORSTED COMPANY. This photograph shows the interior of the Hudson Worsted Company, located on Broad Street. (Stark.)

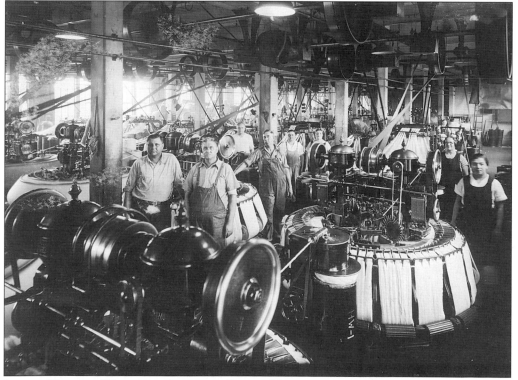

INSIDE HUDSON WORSTED COMPANY. Pictured here is another view of the inside of the Hudson Worsted Company on Broad Street. (Stark.)

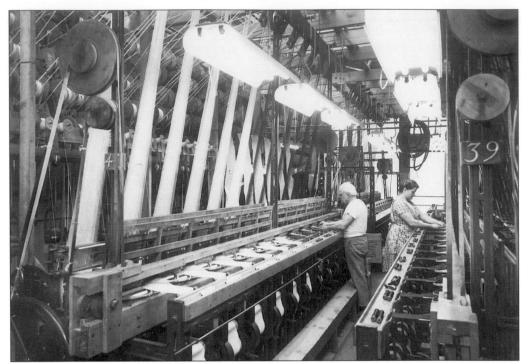

DOUBLE-SHUTTLE POWER. The double-shuttle cross-shot loom was invented by Thomas Taylor in 1888. It was built in Hudson to Taylor's specifications to weave a special shoe gore called "Satin Shugor." Operating the loom are Roberto Benatti and Marie D'Amici.

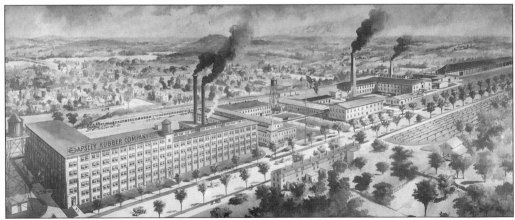

APSLEY RUBBER COMPANY. This artist sketch shows the design proposed for the new Apsley Rubber Company.

Five
WHERE WE SHOPPED

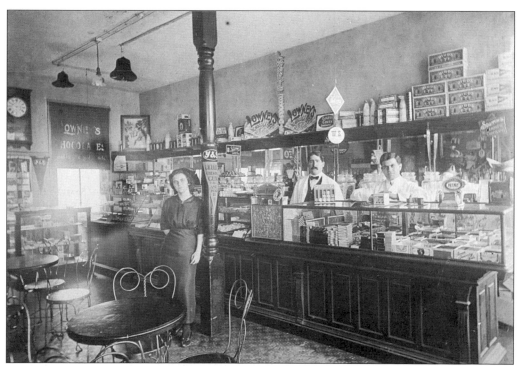

ROBERT WOODARD STORE. Bob Woodard's variety store, located at 81 Main Street, was a very popular gathering place. The store sold ice cream, cigars, magazines, and many other things.

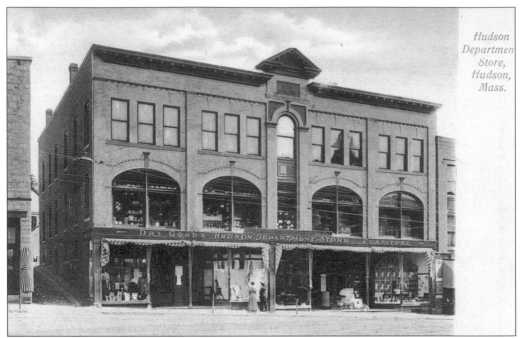

Hudson Departmen Store, Hudson, Mass.

HUDSON DEPARTMENT STORE. Formerly the Hudson Department Store, this building now houses the Crest TV and Appliance Store.

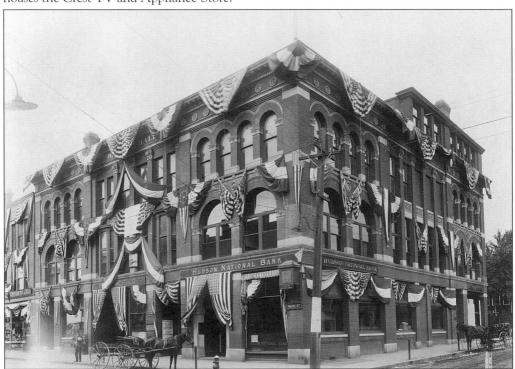

HUDSON SAVINGS BANK BUILDING. This 1916 photograph shows the Hudson Savings Bank building decorated for the town's 50th anniversary. The post office was located here on Main Street, with professional offices on the second floor and the Masonic Order on the top floor.

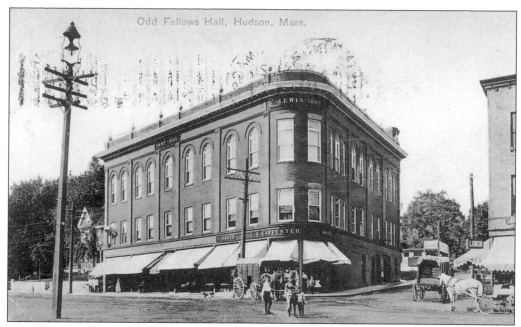

ODD FELLOWS HALL. The Odd Fellows Hall, located on Washington Street at Wood Square, was formerly known as the R.B. Lewis Building.

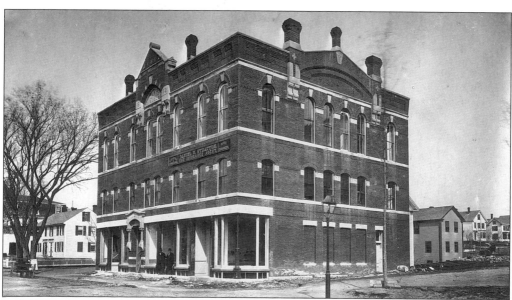

L.T. JEFTS BLOCK. This 1880 photograph shows the Jefts block, which is situated next to the town hall. The first floor contained stores. The second floor housed a savings bank and police courtroom. The third floor, which contained Everett Hall and dining room, was destroyed by fire in 1951.

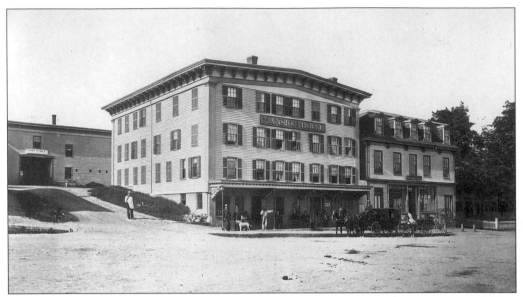

MANSION HOUSE. The Mansion House was located on Main Street at the current site of Crest TV & Appliance. It was built in 1843 as Cox's Tavern and later became Hudson's first hotel. Remodeled in 1856, it burned in the fire of 1894.

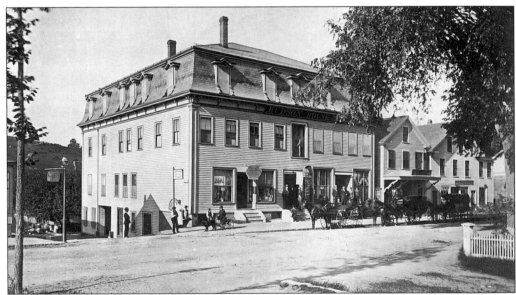

HUDSON HOUSE. The Hudson House was located on Main and Market Streets. Unlike many Hudson buildings, the Hudson House escaped both the fire of 1880 and the fire of 1894. In the 1880 fire, flames that took a section of neighboring houses were stopped just short of the Hudson House. In the great fire of 1894, the flames approached from the other side and again were stopped just before reaching the Hudson House.

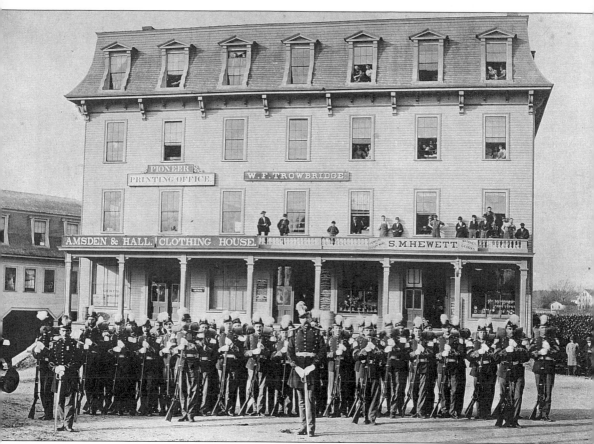

COMPANY I, 5TH REGIMENT. In November 1872, Company I, 5th Regiment, returns from guard duty at the Great Boston Fire. Among them are Capt. Henry S. Moore, front center; 2nd Lt. John F. Dolan, on Moore's right; Sgt. Isaac S. Kennedy, at the right of the line; Sgt. Charles A. Mayo, front of right center; Corp. Lewis T. Howe, front of left center; and Corp. Fred O. Welsh (acting sergeant), at left front. Others include, front rank, from right of company: musician Charles P. Jackson; Sgt. Alfred Dakin; and Pvts. Walter S. Bruce, unidentified, Thomas O'Donnell, Louis Lucier, George Atkinson, Fred Wood, unidentified, Henry Regan, unidentified, William Worcester, Louis Andrews, and Alfred Baker; also Sgt. Philander Ware; William Frost; and rear, behind Lucier, Edward Comery.

ADVERTISING HUDSON STORES. These ads for Hudson stores were taken from a special publication printed to celebrate the town of Stow's bicentennial on May 16, 1883.

68

YOUR PATRONAGE IS APPRECIATED. Shown here are ads for Hudson stores and industries that were taken from a publication printed to celebrate the May 16, 1883 bicentennial of the town of Stow.

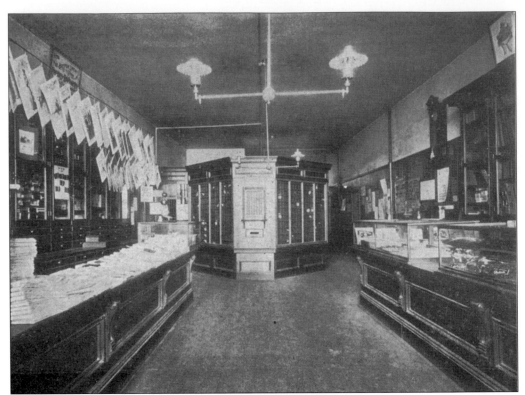

POST OFFICE AND WORCESTER'S NEWSROOM. This building housed Hudson's post office and the newsroom of the *Worcester Telegram*. Built in 1894, it is located on the south side of Wood Square.

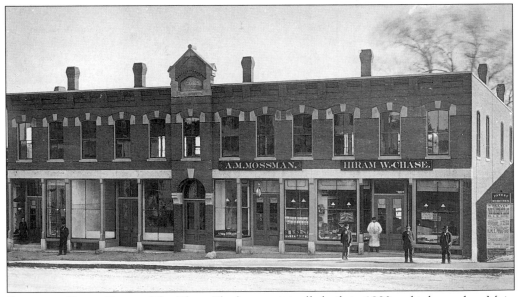

ORIGINAL CHASE BLOCK. The Chase Block was originally built in 1880 and is located on Main Street. A third floor was added later. The building burned in the great fire of 1894 and was rebuilt a year later. The new building also was destroyed by fire, in 1935.

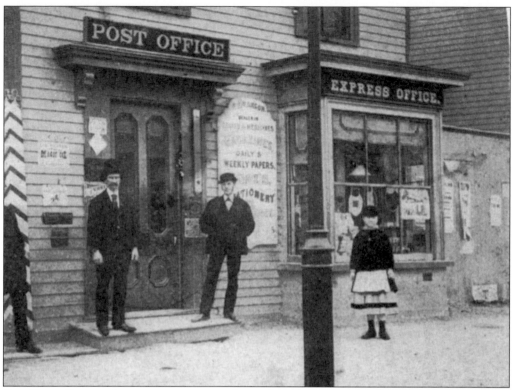

OLD POST OFFICE. At noon, at recess, and at night, scholars visited the old post office on the south side of Wood Square, looking for their mail.

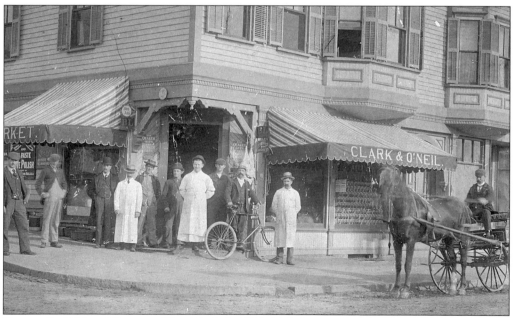

CLARK & O'NEIL MARKET. The Clark & O'Neil Market was located on corner of Manning and Main Streets, where Poplin Furniture now stands.

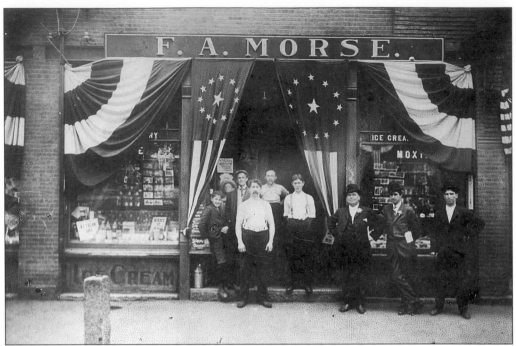

F.A. Morse Store Ice Cream Store. Besides selling ice cream and other treats, this Main Street store also featured Moxie soda. The store was later owned by R.S. Woodard.

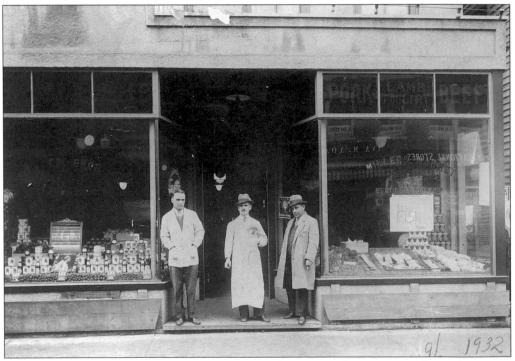

Miller's Market, 1932. Miller's was a very popular meat and grocery store located on Main Street. Shown standing in front of the store are, from left to right, James Miller, Vasil Costa, and ? Botka.

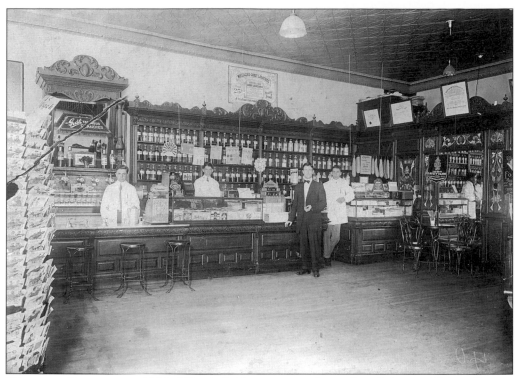

WHEELERS PHARMACY, 1912. Wheeler's Pharmacy was located on Felton and Main Streets. Shown here, from left to right, are Edward Costello, Chester Dolan, Charles Noyes, and proprietor Carleton B. Wheeler.

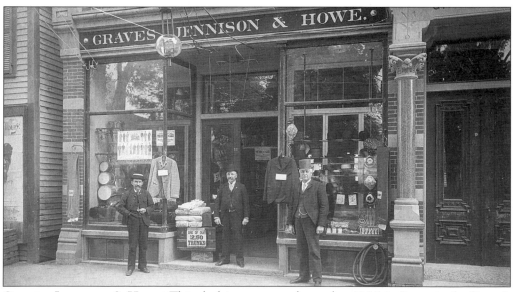

GRAVES, JENNISON & HOWE. This clothing store was located at 49 Main Street in the Grave's Building. Standing in front of the store are Louis Howe, Mr. Jennison, and A.K. Graves.

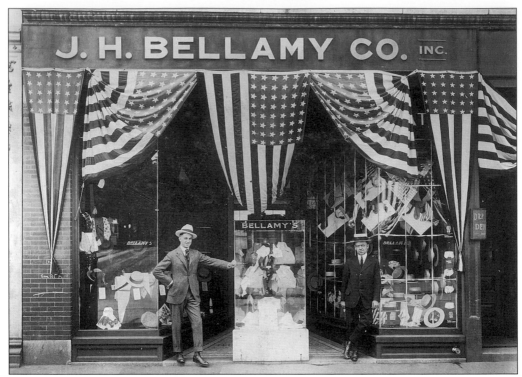

J.H. Bellamy Company Store. Another Main Street store that was in business for many years was the J.H. Bellamy Company.

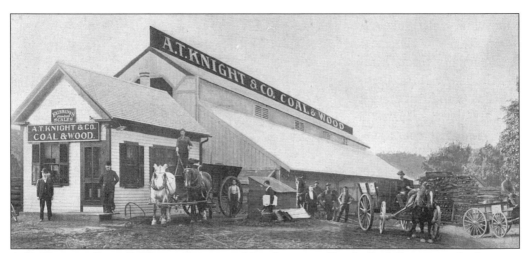

A.T. Knight Coal & Wood Company. Now known as Knight Fuel Company, the business was started by Arthur T. Knight in 1899 and provided anthracite and bituminous coal and firewood to the residents of Hudson. The company is currently owned by David and Nancy Knight Webster, the fourth generation of the Knight family to run the business.

Six

WHERE WE WORSHIPPED

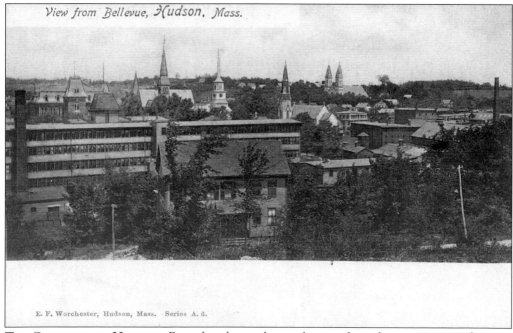

View from Bellevue, Hudson, Mass.

E. F. Worchester, Hudson, Mass. Series A. 6.

THE CHURCHES OF HUDSON. Four church steeples can be seen from this view on top of Mount Bellevue, or Pope Hill. On the left is the town hall, followed by the Baptist (Federated) church with two steeples, the Unitarian church, the Methodist church, and St. Michael's Church, which also has two steeples.

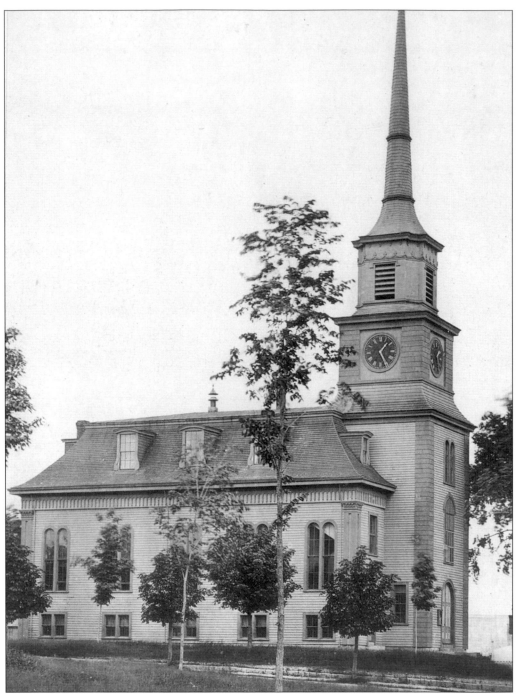

UNITARIAN CHURCH. This church was built in 1861 and was the site of the first town meetings in 1865. The clock in the tower has only three faces. According to reports, one of the most generous donors to the church was not on good terms with Francis Dana Brigham who owned a house nearby on Church Street. The donor declared that he would not have Brigham setting his watch each day by a clock that he helped to fund. The face of the clock tower that overlooked Brigham's house, therefore, was left blank.

GRACE BAPTIST. Grace Baptist Church on River Road is Hudson's newest church.

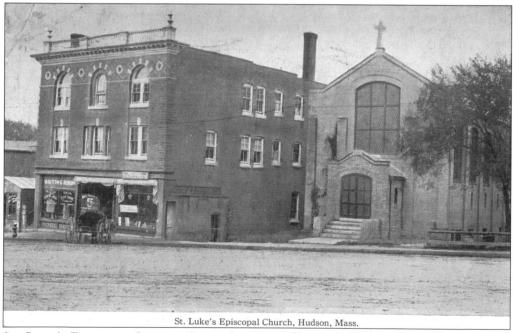

St. Luke's Episcopal Church, Hudson, Mass.

ST. LUKE'S EPISCOPAL CHURCH. Located in Wood Square, with the Chamberlain Block on the left, is St. Luke's Episcopal Church, which was dedicated in 1913.

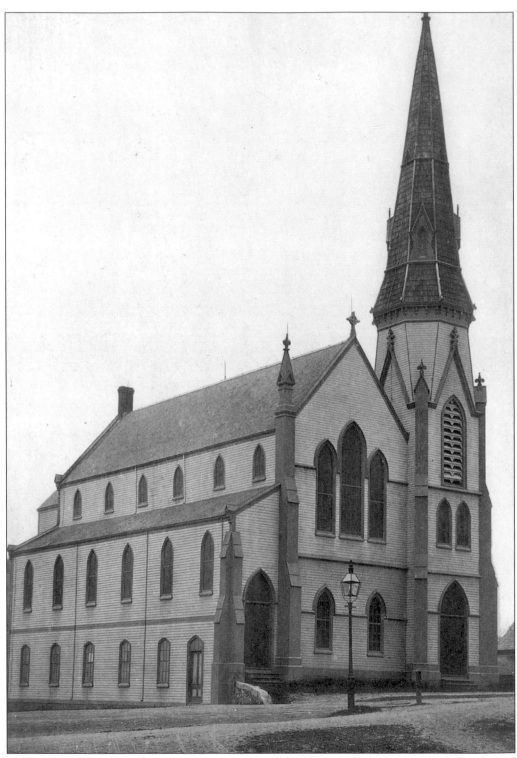

METHODIST CHURCH. The Methodist Church on Main Street was built in 1866 and destroyed by fire in 1911. The site is now occupied by Aubuchon's Hardware store.

METHODIST CHURCH FIRE. The Methodist church, built in 1866 on the corner of Main and South Streets, burned in 1911.

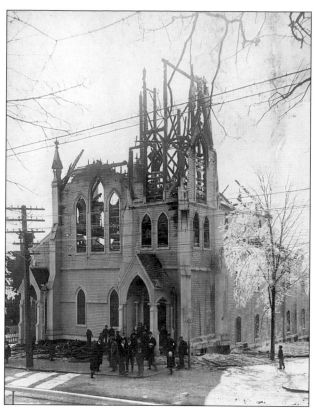

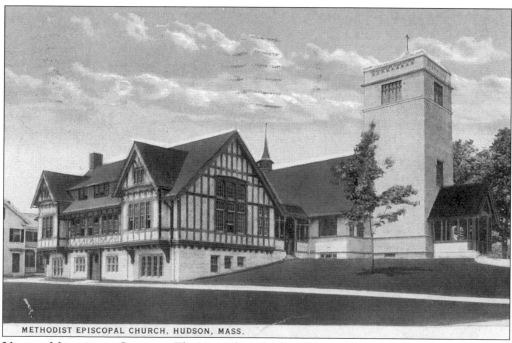

METHODIST EPISCOPAL CHURCH, HUDSON, MASS.

UNITED METHODIST CHURCH. The United Methodist Church, located on Felton and Pleasant Streets, was built in 1912 and was dedicated in 1913.

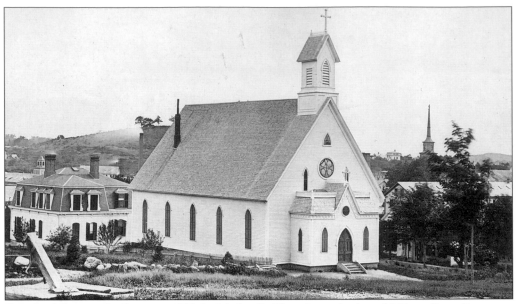

OLD ST. MICHAEL'S CHURCH. Old St. Michael's Church was built in 1869 on Cross Street.

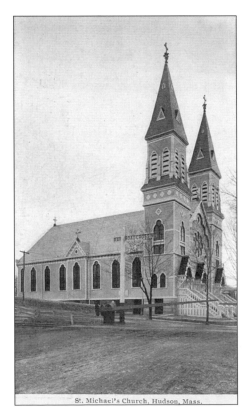

St. Michael's Church, Hudson, Mass.

ST. MICHAEL'S CHURCH. This St. Michael's Church was built in 1889 on Manning Street, which at the time was called Maple Street. The street name was changed to honor two Manning brothers who were killed in World War I. The steeples of the church were lowered after the 1938 hurricane.

CHRIST-THE-KING CHURCH. In 1928, the French Catholic congregation purchased the former Congregational church and rebuilt it as Christ-the-King Church.

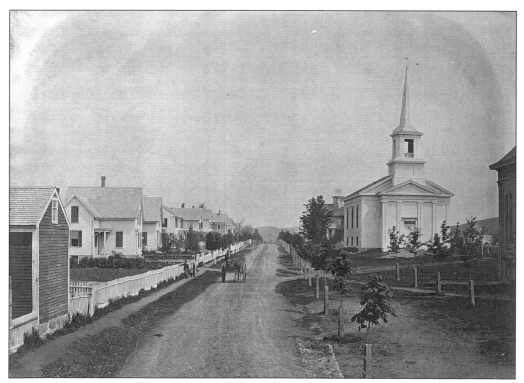

BAPTIST CHURCH. The first church in Feltonville was the Baptist church, built in 1851 on Church Street.

BAPTIST CHURCH. This Baptist church was dedicated in 1871 on the site of the old church. In 1918, it became the Federated Baptist-Congregational Church. A fire destroyed the building in 1965. On the site today is the Boys and Girls Club.

CONGREGATIONAL CHURCH. The Congregational Society was organized and met in Temple Hall. The Congregational church was built on the corner of Green and Central Streets in 1889 and was dedicated in 1902. The church became federated with the Baptist church in 1918, and the building was used as a community hall. In 1928, the building was sold to the French Catholics, who developed it into Christ the King Church.

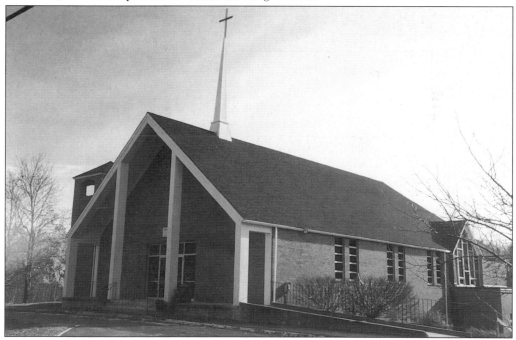

FIRST FEDERATED CHURCH. Located on Central Street, the First Federated Church was dedicated in 1967.

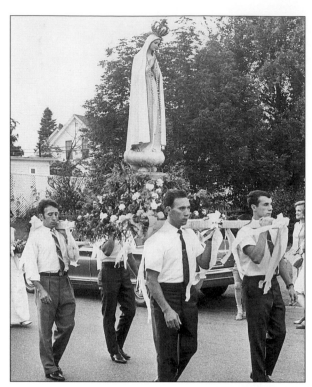

FEAST OF THE HOLY GHOST. The Feast of the Holy Ghost includes a procession that takes place in June and travels from St. Michael's Church to the Portuguese Club on Port Street.

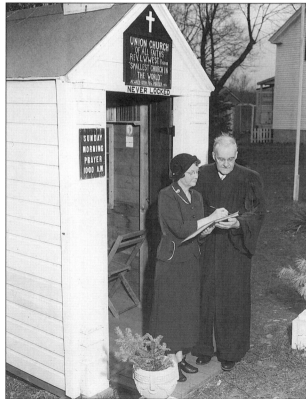

UNION CHURCH OF ALL FAITHS. This small church was located on Central Street. The Rev. Louis W. West was the pastor and the builder of the church. He is shown with Kathryn L. Lamsom, who was the 2,000th person to register at the church.

Seven

WHERE WE
WENT TO SCHOOL

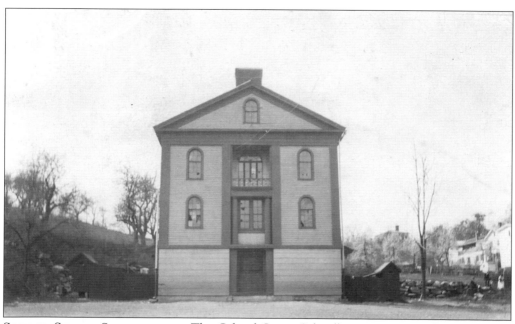

SCHOOL STREET SCHOOLHOUSE. The School Street Schoolhouse was erected in 1854 and abandoned in 1925.

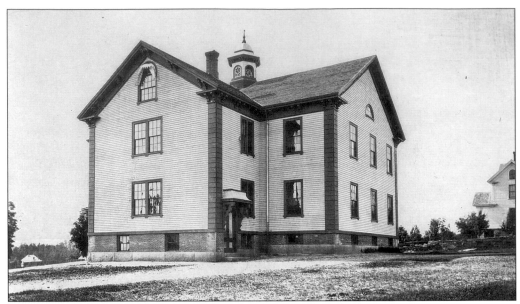

OLD HIGH SCHOOL BUILDING. Built in 1867 on High Street, this building was used as a high school until 1882. After that, it was used as a grade school for many years.

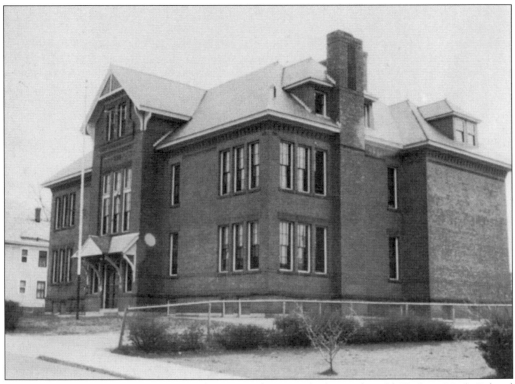

HUDSON HIGH SCHOOL IN 1882. This 1882 photograph shows the old Hudson High School on Felton Street. Today, the remodeled building is a condominium complex.

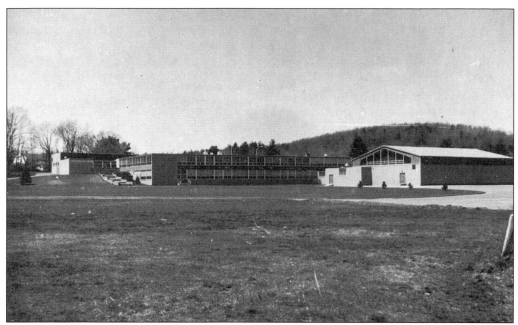

HUDSON HIGH SCHOOL, 1956. This high school was built on Packard Street to replace the old one. In 1970, a still newer high school was built and this building became a middle school. The middle school was named for Carmela A. Farley in recognition of her 53-year teaching career in Hudson schools. In 1999, the building was remodeled and enlarged for 550 students in grades one to five.

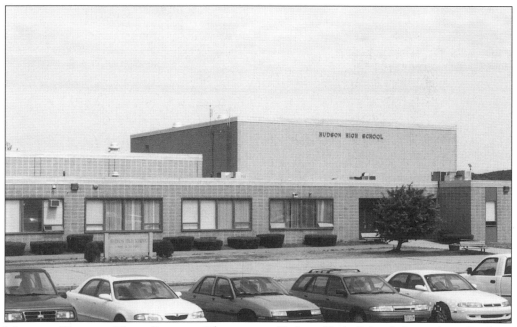

MODERN HUDSON HIGH SCHOOL. The current Hudson High School, located on Brigham Street, was built in 1970.

OLD GREEN STREET SCHOOL. The old Green Street School was built in 1878. It was used until 1924, when it was torn down so that a house could be built on the site.

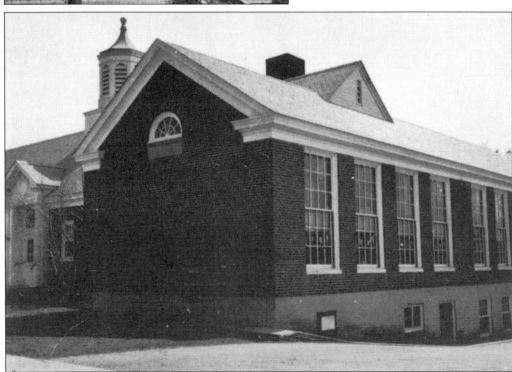

LINDEN STREET SCHOOL. Built in 1924, the Linden Street School replaced the Green Street School. Today, the converted building is used as condominiums.

OLD BROAD STREET SCHOOL. The old Broad Street School was built in 1867, soon after Hudson became a town. The school was used until 1924. The New Broad Street School, shown at the bottom of the page, was built on the same lot.

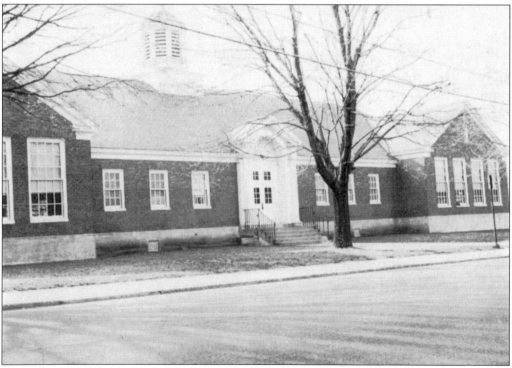

NEW BROAD STREET SCHOOL. Built in 1924 to replace the old wooden Broad Street School, this building is currently the site of the Cora Hubert Kindergarten Center.

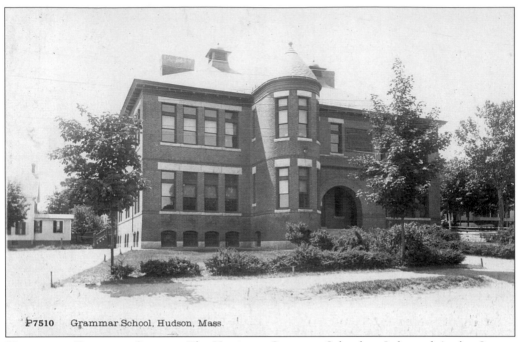

P7510 Grammar School, Hudson, Mass.

HARRIMAN GRAMMAR SCHOOL. The Harriman Grammar School on Lake and Apsley Streets now houses the school administration offices.

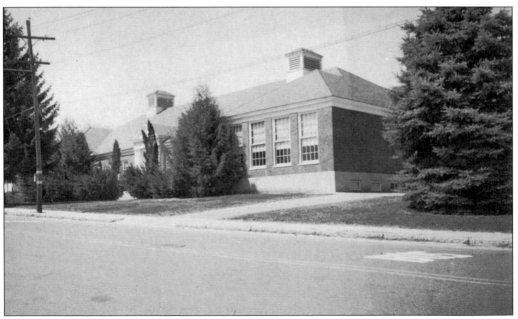

PACKARD STREET SCHOOL. Built in 1924, the Packard Street School is now the site of the Hudson Police Department.

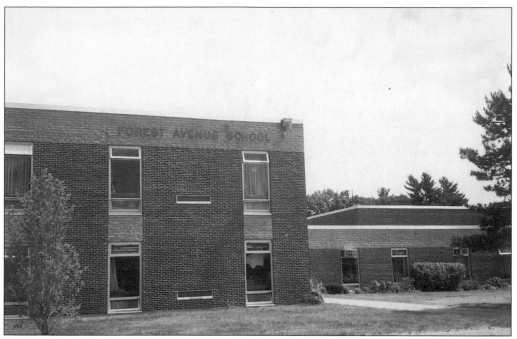

FOREST AVENUE SCHOOL. One of three grade schools in Hudson, the Forest Avenue School is the most recently built school.

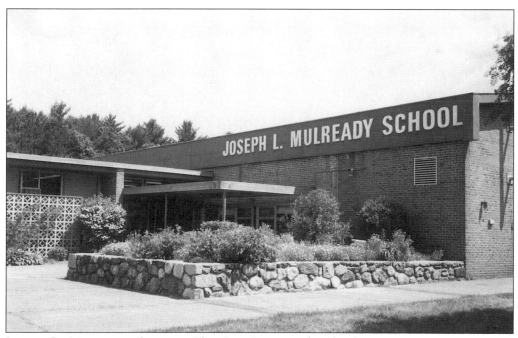

JOSEPH L. MULREADY SCHOOL. The Cox Street grade school was renamed for Joseph L. Mulready, a former school superintendent and a well-loved high school principal.

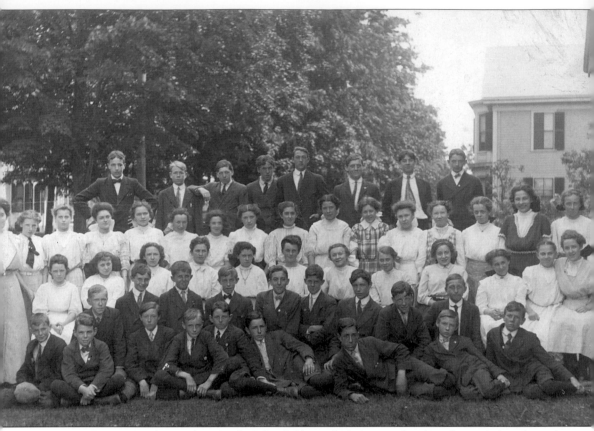

Class Of 1913. The Hudson High School Class of 1913 poses for this photograph, taken in 1910 at the school on Felton Street. Students in the class are, from left to right, as follows: (first row) Charles Cunningham, Ralph Ruggles, George Higgins, Howard Ricker, William Schofield, Ronan Merrigan, Rimby Beaton, Walter Conlin, and Joseph Berry; (second row) Harvey Comey, Carleton Morse, Murray Moore, George Hall, Donald Lyford, Lucius Groves, Edward Wetherbee, Edward Kearney, and Frank Whitman; (third row) Catherine Lynch, Jeannette Jacobs, Florence Davey, Emma Bowser, Helen Plant, Irene Noon, Julia Walsh, Florence Coolidge, Helen Dupree, Charlotte MacLeod, Bernice Peters, and Grace Nolan; (fourth row) Ethel Munroe, Ethel Peters, Bessie Feeney, Sybil Cox, Mildred Collins, Grace Reddy, Grace O'Donnell, Violet Mitchell, Margaret Purcell, Ora Manning, Ruth Howe, Florence Hatch, Edna Haynes, Ruby Drew, and Grace Magorty; (fifth row) Franklin Fox, Emily Vallier, Nathan Kroll, George Richardson, Edward Wall, Leo Coggins, Paul Castigloni, and Franklin Lewis.

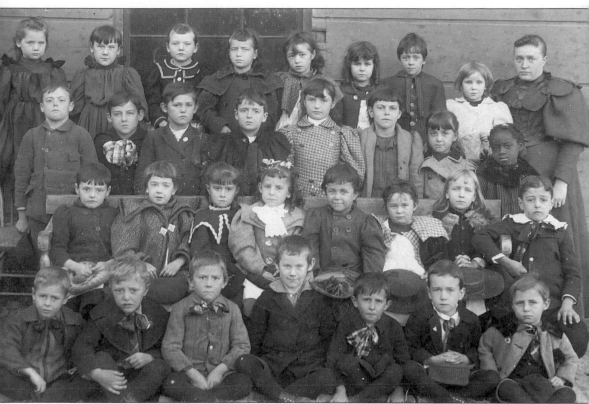

SCHOOL STREET PRIMARY SCHOOL CLASS. At the School Street Primary School, a class taught by Cora Wood poses for this photograph, taken on October 22, 1896. Students are, from left to right, as follows: (front row) unidentified, Fred Clark, unidentified, Charlie Bowser, Emil Bissonette, Alton Burgess, and unidentified; (second row) Hazel Dutton, unidentified, unidentified, unidentified, Marion Beaton, Esther Gill, Ethel Burgess, and unidentified; (third row) Harry Dutton, unidentified, unidentified, Nellie, unidentified, unidentified, Marjorie Atwood, and P. Allen; (fourth row) unidentified, Ella Bowser, Hazel ?, unidentified, unidentified, Ada Jackson, Eleanor Beaton, Molly Jackson, and Cora Wood.

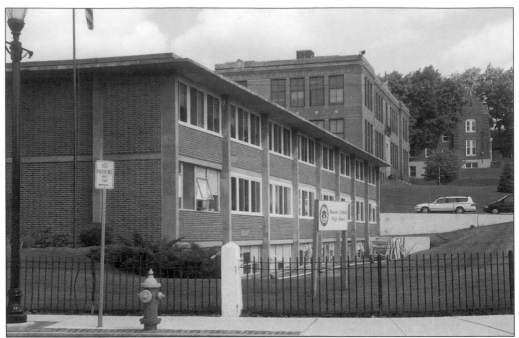

HUDSON CATHOLIC HIGH SCHOOL. This Hudson Catholic High School is located on Main Street, adjacent to St. Michael's School and the convent on High Street.

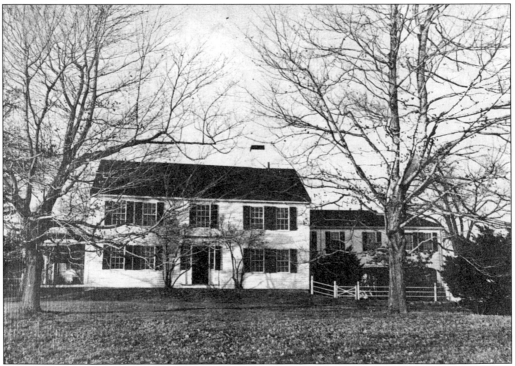

HUDSON INSTITUTE. The Hudson Institute was a local college consisting of six buildings on a 52-acre campus. This photograph shows a Hudson Institute building on Hosmer Street. The institute closed on April 28, 1975.

Eight

OUR SPECIAL HOUSES

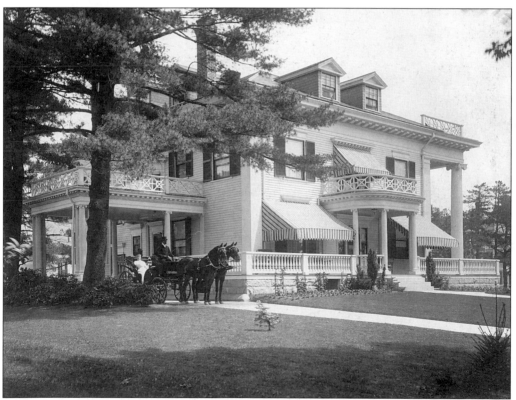

APSLEY MANSION. This Southern Colonial home was built in 1905 on Pleasant Street. Constructed with the most expert workmanship, the house contained luxurious furnishings and the latest in electrical and telephone conveniences. Home recreation was an important feature of this mansion: it had a room for billiards and a bowling alley.

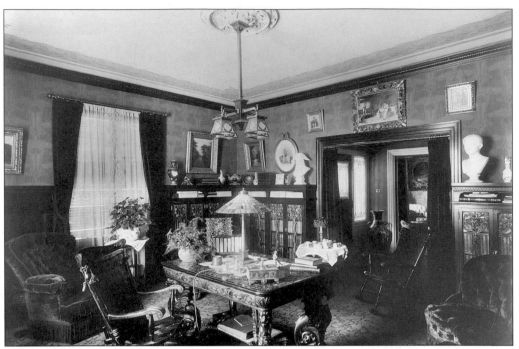

APSLEY MANSION LIBRARY. The library is the room where all the family business was transacted, at this fancy desk and rocking chair. For a library, the room seems to have very few books showing.

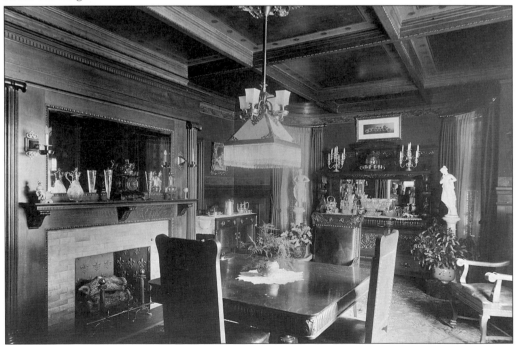

APSLEY MANSION DINING ROOM. This very sturdy dining room with its beamed ceiling and fireplace had a table that only seated four but which likely expanded, when needed, to hold a large number of guests.

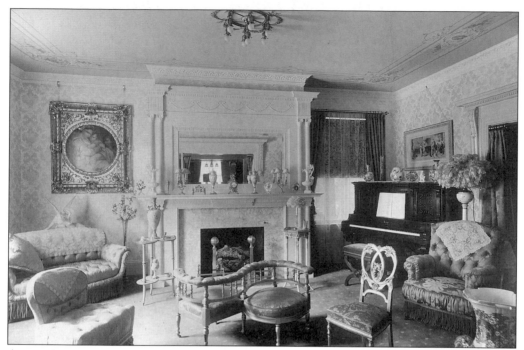

APSLEY MANSION LIVING ROOM. The decor of the living room probably shows the influence of the women of the house: the room is light, and the furnishings are bright. The upright piano in the far corner indicates that the living room was also used as the music room.

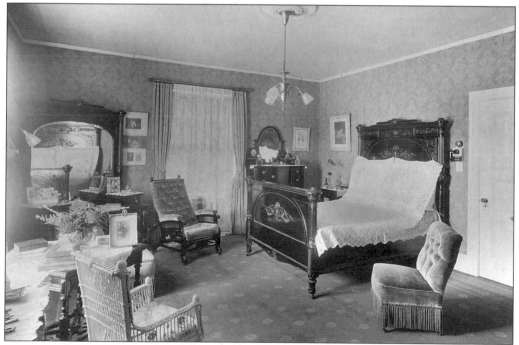

APSLEY MANSION BEDROOM. This bedroom had many chairs but no built-in clothes closets. The clothes of the room's occupants were stored in stand-alone closets or massive dressers, one of which is shown on the left.

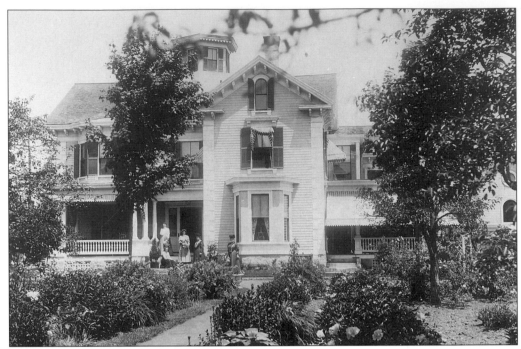

BRIGHAM HOME. Located at 29 Church Street, this house was built by Francis D. Brigham *c*. 1850 and was once the rose garden of the Brigham estate. William H. Brigham lived in the house until his death in 1911, and his wife continued to live here until 1936. This picture was taken in 1912. The house is now used as Hudson's Senior Center.

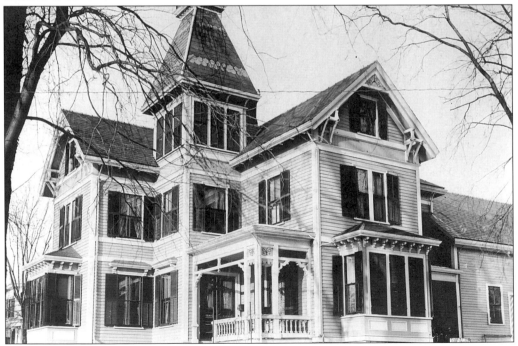

S.A. HOLT HOUSE. The S.A. Holt house, located at 3 Lincoln Street just off the square, was built *c*. 1880. In 1962, this house also served as the town clerk's office.

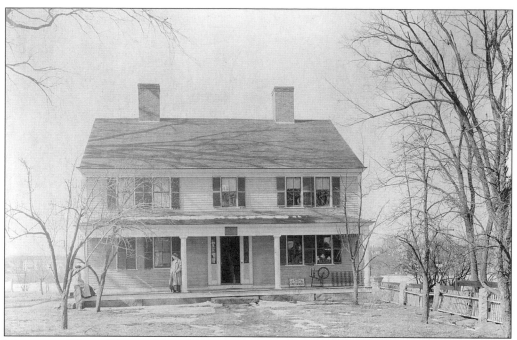

MARSHALL WOOD HOUSE. Not all houses in Hudson were mansions. Most were similar to the Wood house, or even more basic. The sign on the porch says "C.E. Burgess—Antiques." The armory is now on the site formerly occupied by this house.

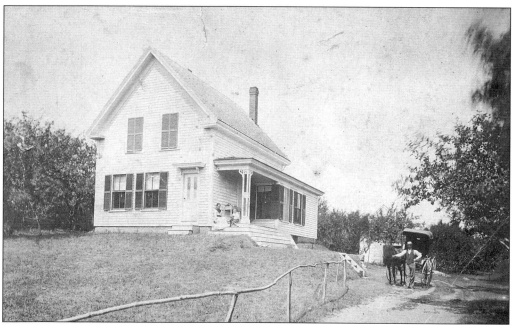

COOLIDGEVILLE. Every house in the Coolidgeville area was built by a member of the Coolidge family. This one, located at 193 Central Street, was built in 1870 and is the birthplace of Dr. William D. Coolidge. This picture, taken *c.* 1878, shows William, his mother, Alice, and his father, Albert.

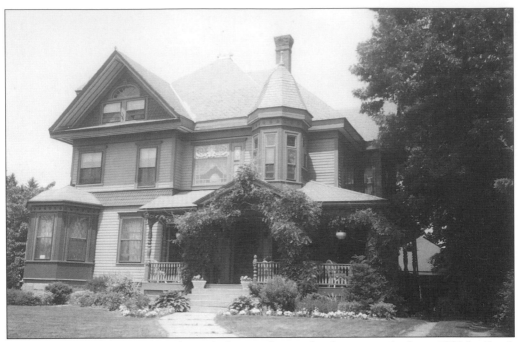

CHAMBERLAIN HOUSE. Located at 25 Pleasant Street, this house was built in 1893 by Frank Chamberlain, a Hudson shoe manufacturer.

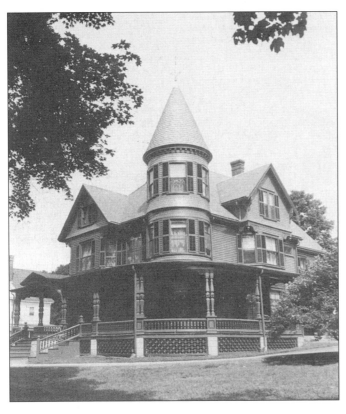

MOSSMAN HOUSE. The Col. Adelbert Mossman house dates back to 1901. Mossman founded Hudson's militia.

MANSION. Hudson shoe manufacturer Luman T. Jefts built this 32-room brick mansion at Felton and Pleasant Streets in 1887, as "a continual source of comfort to himself but also an honor and ornament to the town." The mansion is now an apartment house.

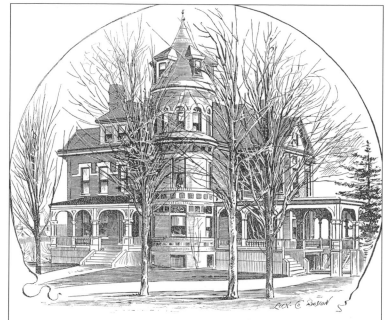

RESIDENCE OF HON L. T. JEFTS, CORNER OF PLEASANT AND FELTON STREET

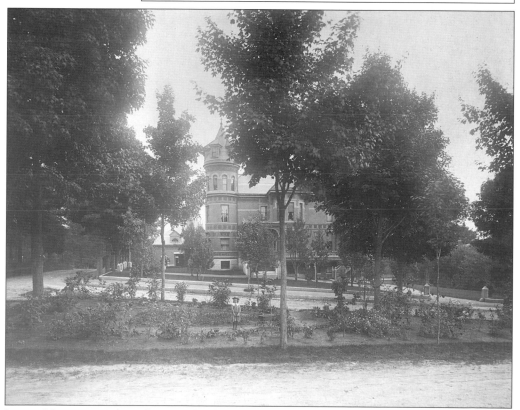

JEFTS MANSION. This photograph shows the grounds and garden that surrounded Jefts Mansion.

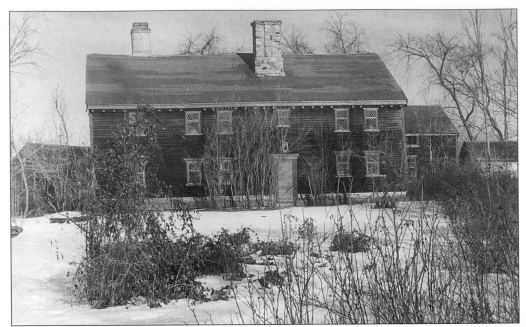

GOODALE HOUSE. The Goodale house on Chestnut Street is Hudson's oldest house. Built in 1702, it started out as a one-room house on Parmenter Road.

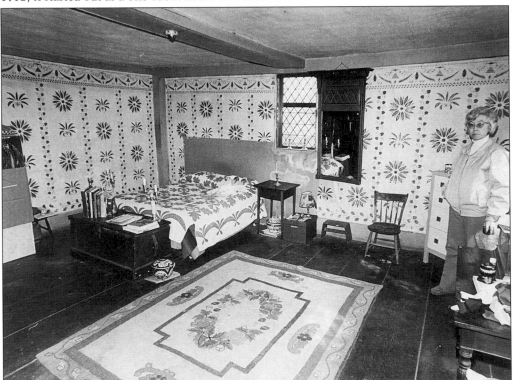

INSIDE THE GOODALE HOUSE. The large rug in this room of the Goodale house helped keep the floor from being very cold in the winter. The gay patterns on the walls were big and large in order to make an otherwise dark room as pleasant as possible.

Nine

THE BIG FIRE AND OTHER DISASTERS

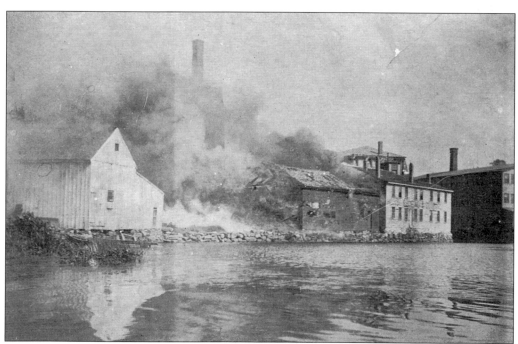

THE GREAT FIRE. This picture shows the beginning of Hudson's great fire of July 4, 1894.

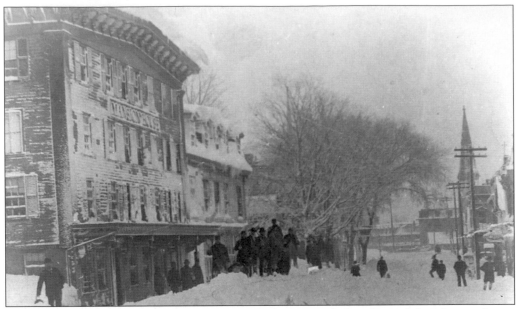

BLIZZARD OF '88. A group of people dig out of a high snowdrift in front of the Mansion house on Main Street after the blizzard of March 13, 1888.

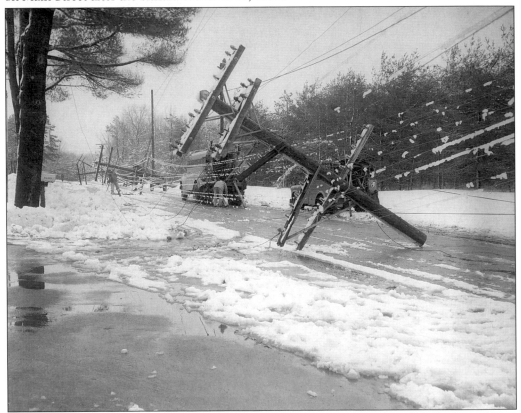

THE WIRES ARE DOWN. Power and telephone wires were lying down on the job after a heavy snow-and-ice storm in the 1940s.

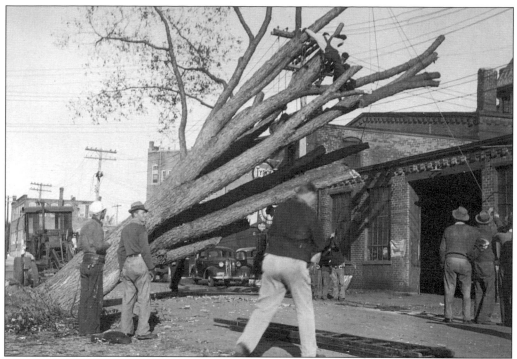

THE TREES ARE DOWN. The hurricane of September 21, 1938, caused this tree to fall in front of the Elm Garage on South Street.

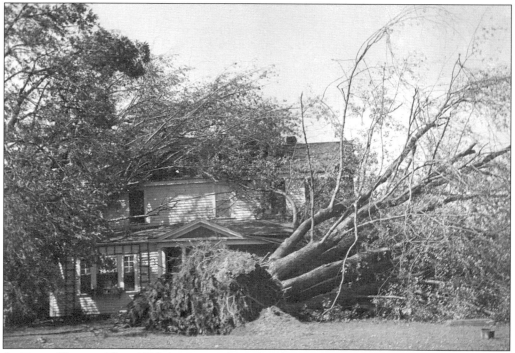

A TREE HOUSE. The 1938 hurricane brought this tree down onto the Kane house on Gospel Hill.

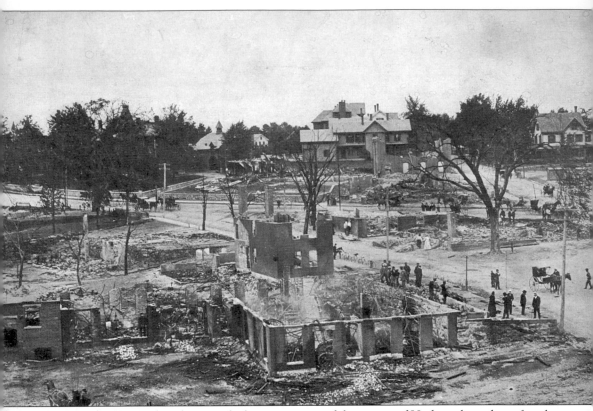

AFTER THE FIRE. This photograph shows a section of the center of Hudson three days after the great fire of July 4, 1894. The fire was started by some boys playing with fireworks. With a lot of Hudson residents, including Hudson firemen, enjoying holiday festivities at Trotting (now Riverside) Park, the fire was able to get a head start.

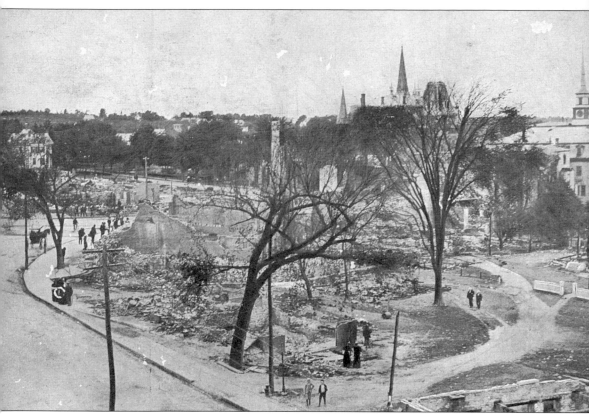

MUCH WAS DESTROYED. Nearly 40 buildings were destroyed, covering an area of more than 5 acres and representing a loss of fully a half-million dollars, all of which was accomplished in less than three hours. The old landmarks vanished early. Silhouetted against the smoldering fire were the few trees that had withstood the fierce heat. Blackened to the roots with branches bare, they loomed up in the darkness like guideposts to where the buildings they had sheltered once stood.

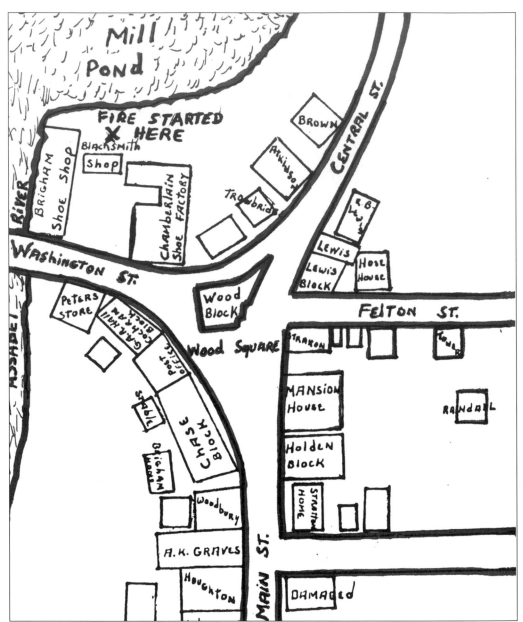

HEART OF HUDSON DESTROYED. About 3 o'clock in the afternoon of July 4, Hudson was struck by the severest fire ever to occur in this vicinity. At that hour in an open shed at the rear of F.M. Chamberlain's shoe factory, some children were playing with firecrackers. In only a few moments, the small fire the children had set assumed alarming proportions. The fire department was seriously handicapped at the start The alarm sounded immediately, but a majority of the townspeople were either out of town or over at Trotting Park. The alarm was not heard at the park, but a dense column of smoke attracted attention. The people quickly deserted the park and rushed into town. They saw at a glance that Chamberlain's factory was doomed. They watched the flames mount quickly to the factory's top story and then leap in the strong west wind toward the other buildings in the square. The intense heat made it almost impossible for the firemen to fight the fire.

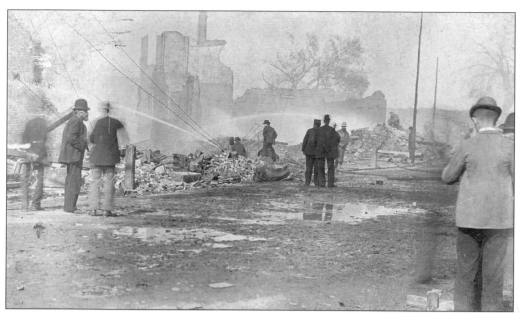

MOPPING UP AFTER THE FIRE. Crews quell the last of the flames of the 1894 fire.

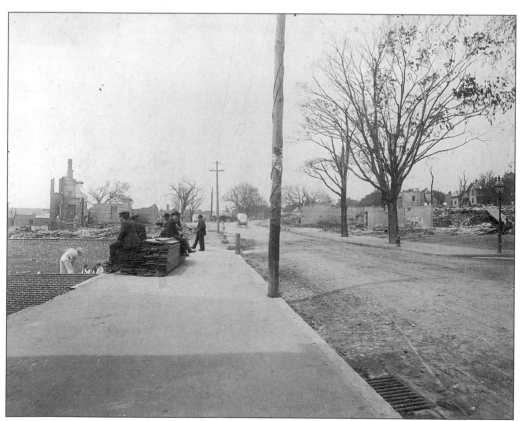

TIME TO REBUILD. Just a few days after the fire of July 4, 1894, the rubbish was being removed and the lumber was being stacked up for rebuilding the fire-ravished downtown buildings.

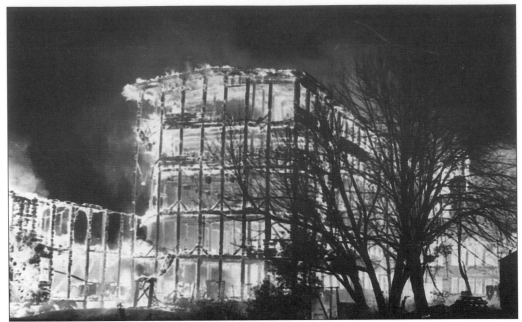

BURNING SHOE COMPANY. The Ascutney Shoe Company on South Street, formerly the F. Brigham & Sons Factory, is shown during a disastrous fire on October 31, 1968.

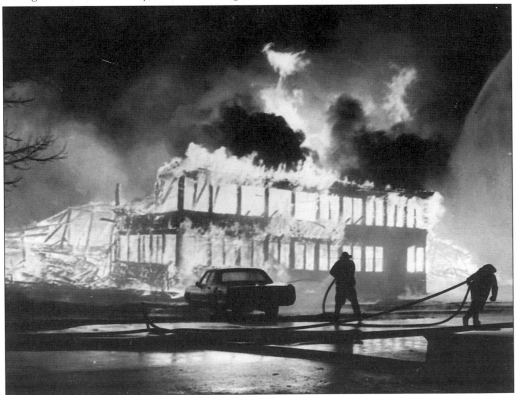

COMPLETELY CONSUMED. This photograph shows another view of the Ascutney Shoe Company fire in October 1968.

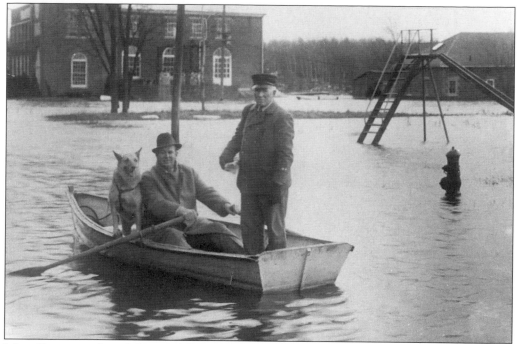

MAIL DELIVERY. Joseph Lovett delivers mail to the Hudson Light & Power building on Cherry Street during the 1936 flood of the Assabet River. Rowing the boat is postmaster Leo Corcoran.

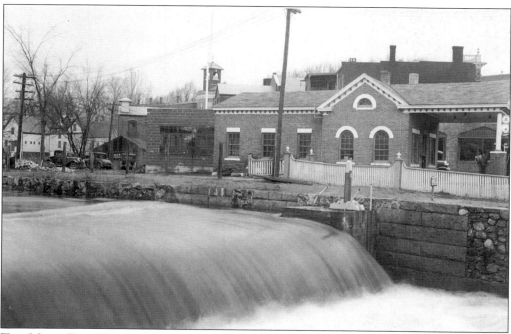

TOO MUCH DAM WATER. Water pours over the otherwise placid Assabet River dam during the 1936 flood. (Fillmore.)

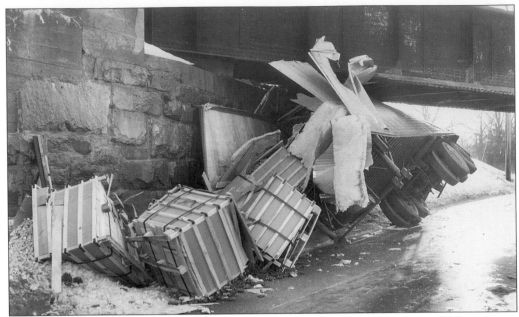

TRUCK CRASH. This truck crashed into the railroad bridge that used to span Wilkins Street (Route 62). Despite posted warnings of height limits, truck drivers frequently ran into trouble trying to fit large trucks under the railroad overpass. (Worcester.)

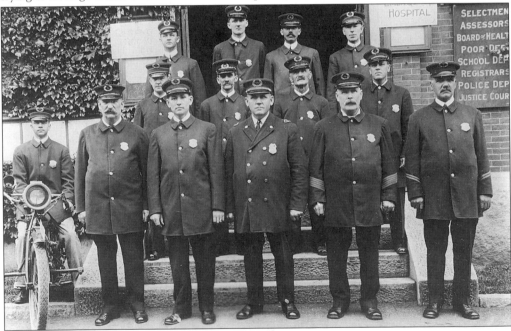

HUDSON POLICE FORCE, 1916. The members of the Hudson Police Force line up in front of town hall during the 50th anniversary. Pictured are, from left to right, as follows: (front row) Arthur H. Robbins, Rudolph Pinder, Thomas H. Hellen, Joseph C. Light, Andrew Magorty, and Theodore Stronach; (middle row) William H. Clark, Alvin J. Jillson, Flavien Morel, and Alfred F. Benway; (back row) J. Frank Cassidy, Frank Henderson, Whitney J. Brigham, and James B. Hayes.

Ten
HOW WE HAD FUN

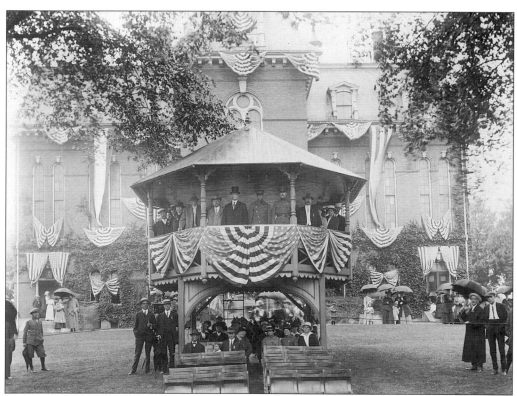

THE BANDSTAND. From the bandstand in front of town hall, Gov. Samuel W. McCall reviews the parade of 1916, which marked the town's 50th anniversary.

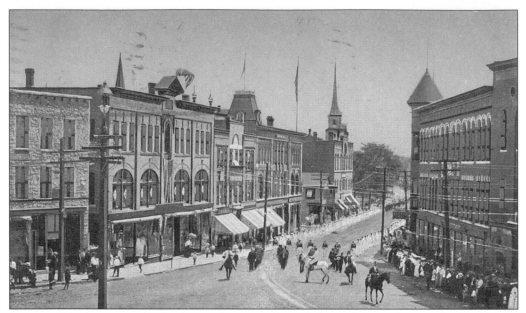

PARADE. The horse unit leads a long column of white-clad marchers in this parade unit coming down Main Street in 1906. Parade watchers hug the shady portions of the sidewalk on what must be a hot summer day, possibly the Fourth of July.

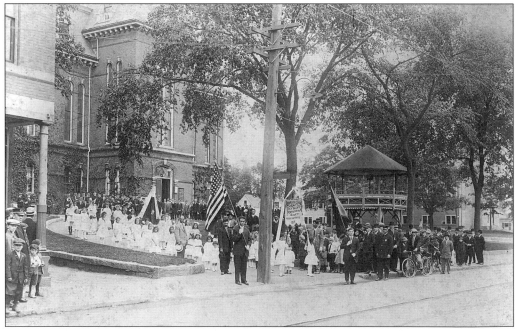

VERY FIRST PROCESSION. This photograph shows the first procession of the Holy Ghost Portuguese Society celebrating Trinity Sunday in 1915. Mr. and Mrs. Grillo of Summer Street were the first sponsors.

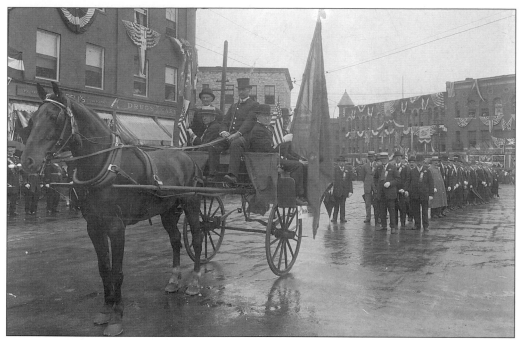

FIFTIETH ANNIVERSARY PARADE. This parade celebrated the 50th anniversary of Hudson in July 1916.

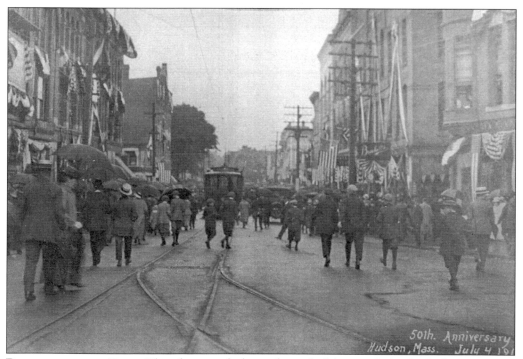

BRINGING UP THE REAR. This photograph shows the end of the parade for the 50th anniversary of Hudson in July 1916.

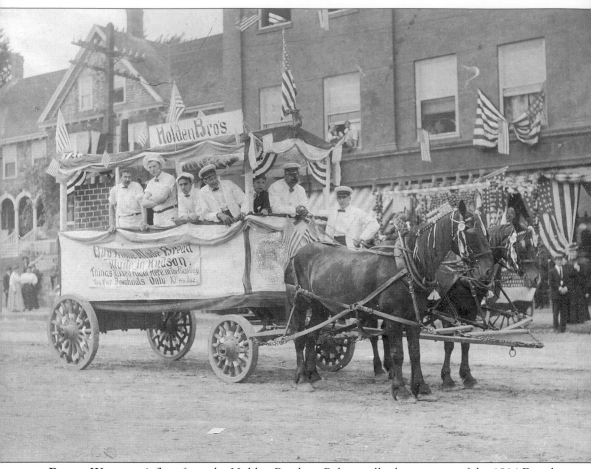

BREAD WAGON. A float from the Holden Brothers Bakery rolls along as part of the 1914 Fourth of July parade. The banner on the side of the wagon reads, "Buy homemade bread, made in Hudson. Things mixed right here in the right way. Try our doughnuts, only 10 cents per dozen."

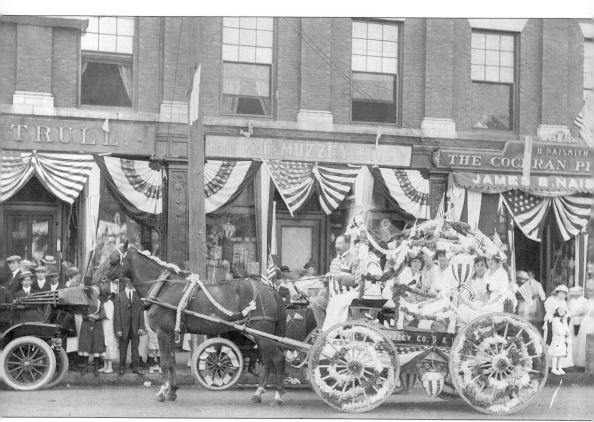

PARADE BELLES. A group of well-dressed women ride on this horse-drawn float presented by the Muzzy Company clothing store in the 1914 Fourth of July Parade.

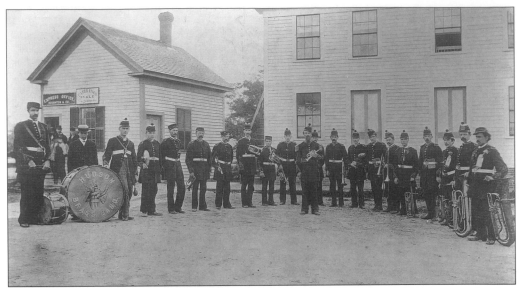

HUDSON BRASS BAND. The Hudson Brass Band stands in full uniform in this photograph taken on June 24, 1877.

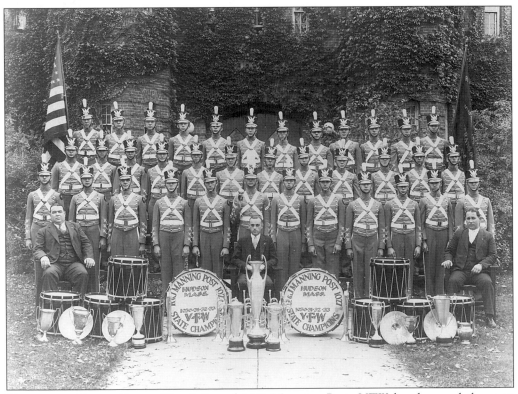

DRUM AND BUGLE TEAM. The R.E. and J.W. Manning Post, VFW band earned the state championship from 1930 to 1933.

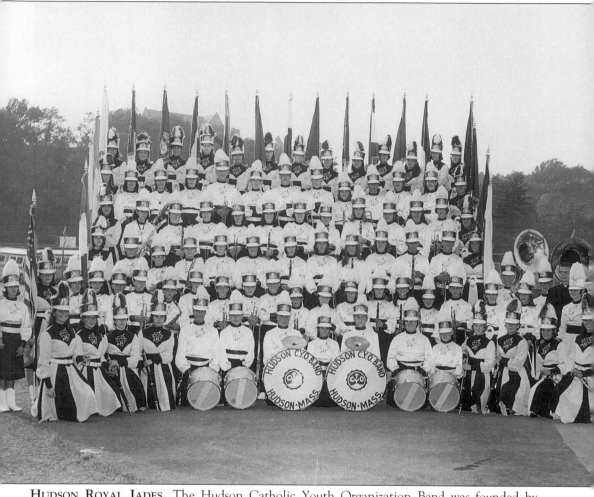

HUDSON ROYAL JADES. The Hudson Catholic Youth Organization Band was founded by Professor Alfred Yesue in 1960.

HUDSON THEATER. The Hudson Theater was built in 1920 on Pope Street. The theater was taken down to erect the Hudson National Bank.

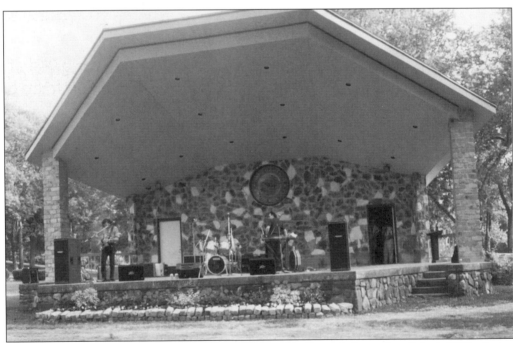

WOOD PARK MUSIC SHELL. The Wood Park Music Shell was dedicated on July 4, 1976, during Hudson's celebration of the U.S. bicentennial. The dream and effort of Victor Dyer, the band shell was only partially completed at its dedication. With the base of the shell in place, many band concerts were played alongside the cooling Assabet River before the shell was completed in 1996.

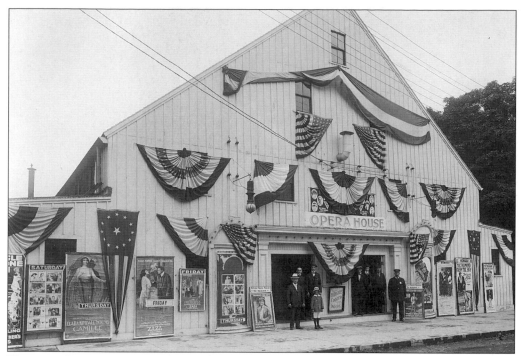

HUDSON OPERA HOUSE. The Hudson Opera House was decorated for the town's 50th anniversary in July 1916. Located on Market Street, the opera house was later opened as the Elm Theater (where Saturday matinees cost only 5¢), and then the Elm Club.

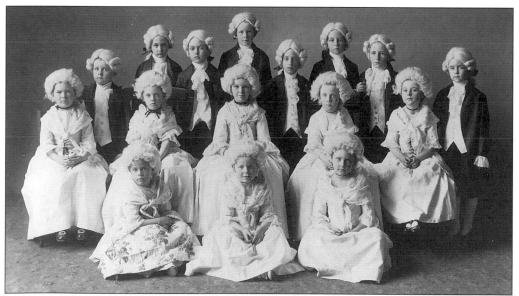

BEN LOVETT'S DANCE RECITAL, 1918. The following people, from left to right, were at this Benjamin Lovett dance recital in 1918: (front row) Roberta Matthews, Pauline Fuller Persons, and Ruth Dakin; (middle row) Margaret McGrath, Esther Murphy, Pauline Stratton, Geraldine Hapgood Thorne, and Camilla Castilooni; (back row) David Wheeler, Albert Shaw, Ralph Lyman, Walter Lovett, Erwin Story, Harry Bunting, Loriman Brigham, and Duncan Persons.

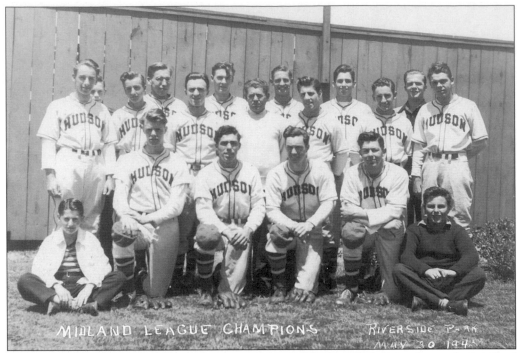

HUDSON HIGH BASEBALL TEAM. The baseball team of Hudson High School won the Midland League Championship in 1945.

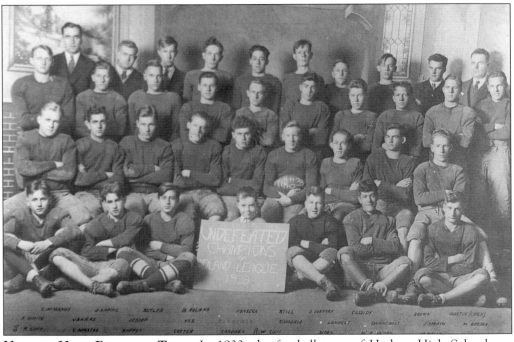

HUDSON HIGH FOOTBALL TEAM. In 1933, the football team of Hudson High School was undefeated and untied.

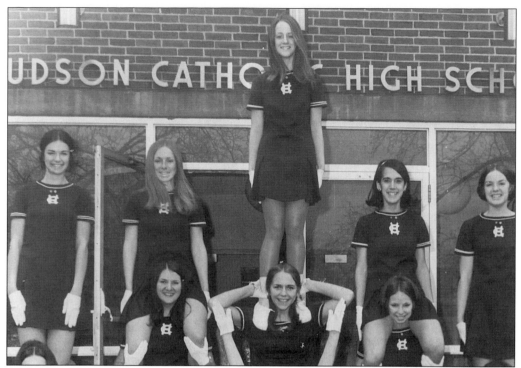

CATHOLIC HIGH CHEERLEADERS. Cheerleaders of Hudson Catholic High School do some cheering in 1967. (Rimkus.)

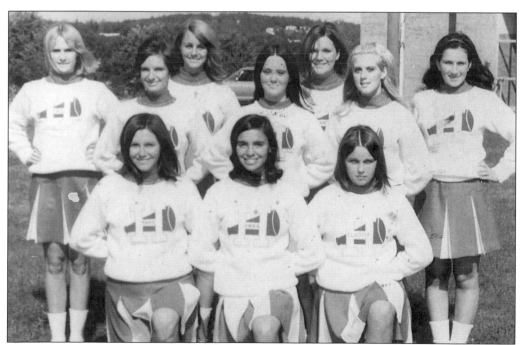

HUDSON HIGH CHEERLEADERS. Cheerleaders of Hudson High School stand ready to lead a cheer for the home team at a football game in 1967. (Rimkus.)

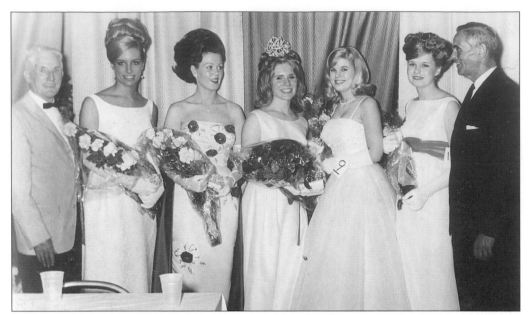

QUEEN AND HER COURT. At the Hudson Centennial Ball in 1966, the queen and her court pose for this photograph. They are, from left to right, William O'Donnell, Joy Tarbell, Marion Saaristo, queen Susan Grigaitis, Joanne Gustafson, Janet Erlandson, and Will Balthazar.

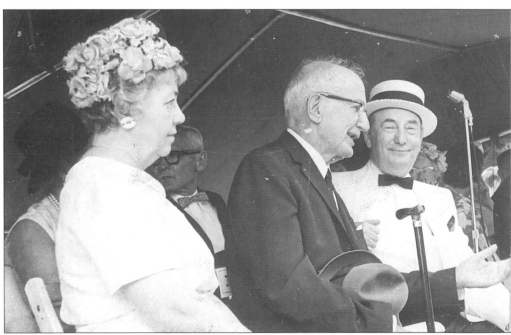

HUDSON CENTENNIAL PARADE MARSHALS. In this 1966 centennial parade photograph, Sen. B.K. Wheeler (center) is surrounded by Mr. and Mrs. Anthony O'Malley.

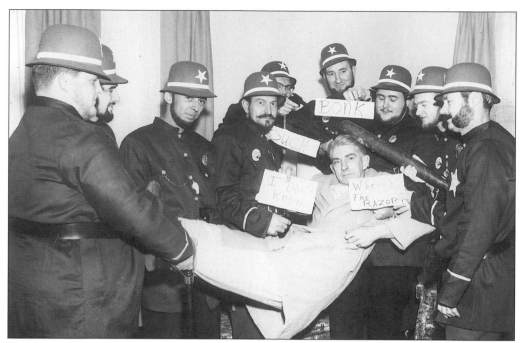

KEYSTONE KOPS. These actors are dressed up for a 1966 centennial event. The person being held is firefighter John Doyle.

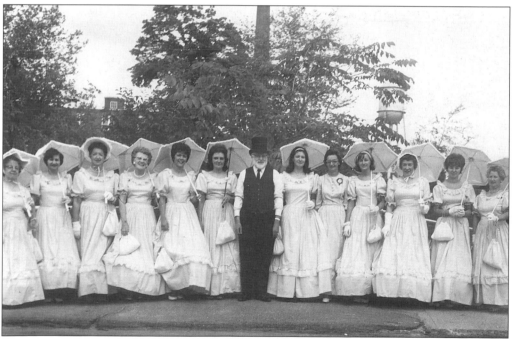

CENTENNIAL BELLES. The Centennial Belles of Thomas Taylor & Company pose with Robert T. Dawes during the town's 1966 centennial celebration.

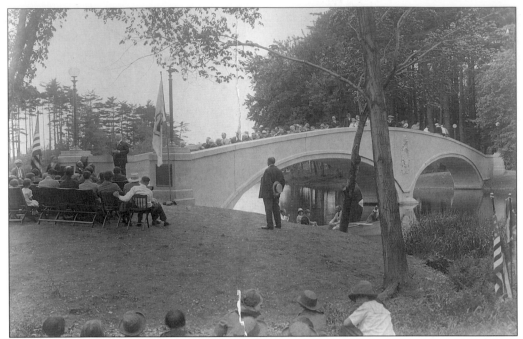

DEDICATION OF TAYLOR BRIDGE. Taylor Bridge connects Wood Park, which was built in 1896, and Apsley Park, which was built in 1913. The bridge was a 1926 gift of Thomas Taylor and his son Frank. The bridge was dedicated on June 12, 1927.

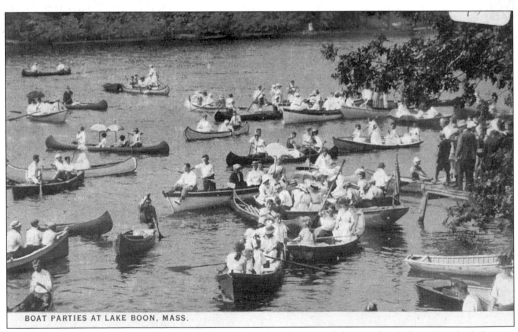

BOAT PARTIES AT LAKE BOON, MASS.

CANOE PARTY. Canoes gather on Lake Boon in order to celebrate the Labor Day holiday, in the early 1920s.

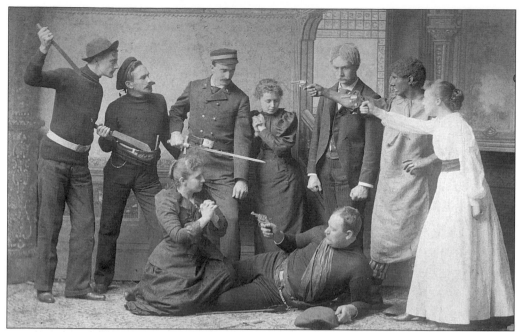

BOUND BY AN OATH. This Gay Nineties drama was performed by the Unitarian Unity Club at the town hall. Pictured here, from left to right, are the following: (front row) Mary L. Eddy and George Peters; (back row) Leslie Dawes, Harry Parks, Ed Worcester, Mary Taylor, Charlie Pingree, Sid Robinson, and Lora Guernsey.

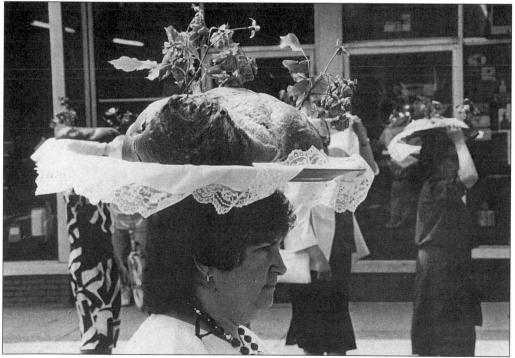

HOLY GHOST PARADE. Special hats are a feature of the Portuguese community's religious parades.

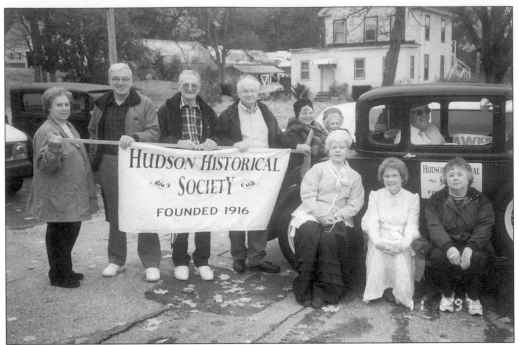

HUDSON HISTORICAL SOCIETY. Members of the Hudson Historical Society turned out on November 20, 1997, for an old-car rally and parade that takes place yearly in Hudson. Shown from left to right are the following: Mildred Linehan, Alan Linehan, Arthur Charbonneau, Lenard Pauplis, (Jeanette Pauplis and Helen Charbonneau in the car's rumble seat), Rosemary Rimkus, Ellen Busch, and Carolyn Pope.

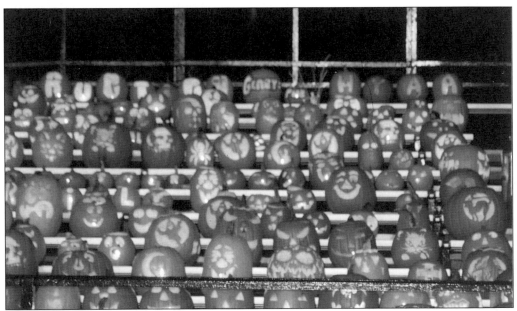

PUMPKIN HEAD. At the first Hudson Pumpkin Fest, held on October 24, 1998, more than 1,100 carved pumpkins were displayed at the high school athletic field.